The Complete Guide to
CHINESE
CALLIGRAPHY

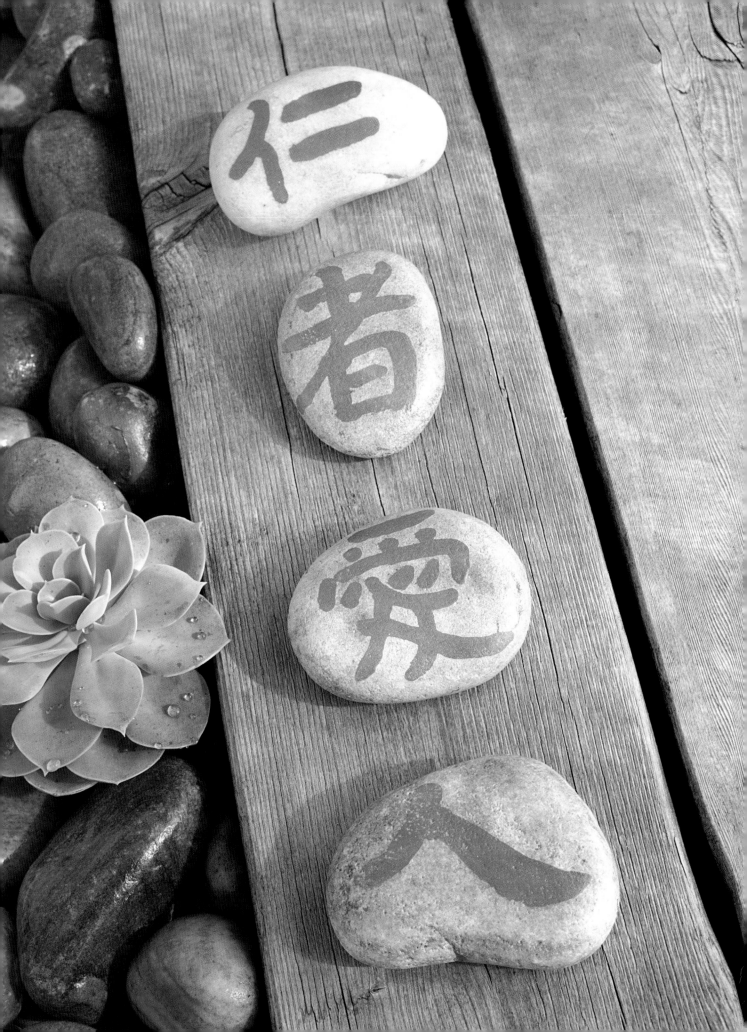

The Complete Guide to
CHINESE
CALLIGRAPHY

Discover the five major scripts
to create classic characters
and beautiful projects

QU LEI LEI

CICO BOOKS

LONDON NEW YORK

Published in 2007 by CICO Books
an imprint of Ryland Peters & Small
519 Broadway, 5th Floor
New York NY 10012

10 9 8 7 6 5 4 3 2 1

A catalog record for this book is available from the
Library of Congress

ISBN-13: 978 1 904991 87 8
ISBN-10: 1 904991 87 4

Printed in China

Editor: Robin Gurdon
Designer: Ian Midson
Photography: Geoff Dann

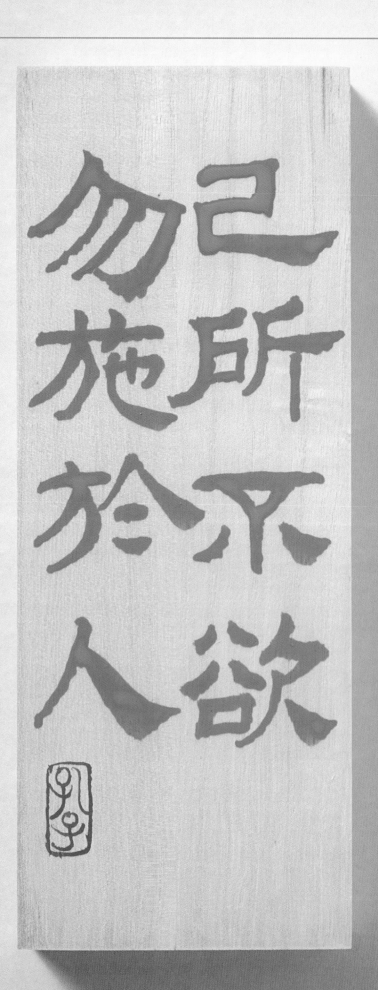

Contents

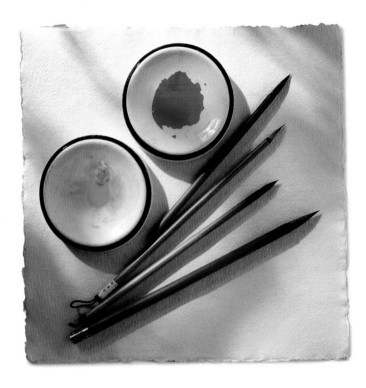

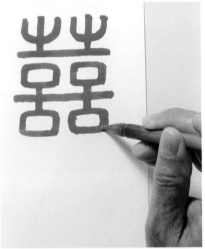

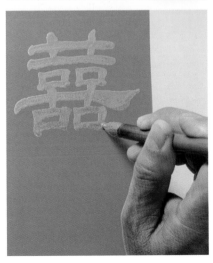

Introduction

CHINESE CALLIGRAPHY AND THE FIVE SCRIPTS

Chronology: Chinese Dynasties			
Xia	21st–16th century BCE	Western Jin	265–316
Shang	16th century–1028BCE	Eastern Jin	317–420
Western Zhou	1027–771BCE	Northern and Southern Dynasties	420–589
Eastern Zhou	770–221BCE	Sui	589–618
Qin	221–207BCE	Tang	618–907
Western Han	206BCE–CE24	Five Dynasties	907–960
Eastern Han	25–220	Northern Song	960–1127
Three Kingdoms	220–265	Southern Song	1127–1279

The very first Chinese characters were the pictographic images representing the world and its contents but although they were simple pictures they were also characters. Their development began about 7,000 years ago, starting from simple linear patterns. Even now, after thousands of years of evolution, the basic elements of the pictographic features remain.

In simple terms, Chinese calligraphy is the art of writing Chinese characters but because it gathers together the ideals of culture, thought, and philosophy, it is treated as the epitome of art. The tools of Chinese calligraphy: the brush, ink, paper, and ink stone—together called the Four Treasures—are also integral to this art. These writing tools become life-time friends to the scholar in his studio, and are thought of as the extension of his soul.

Early on, Chinese calligraphy developed two separate traditions. The first tradition carved characters into bones, metal, and stone. The very first examples were Shang dynasty oracle bones which were religious texts foretelling the future.

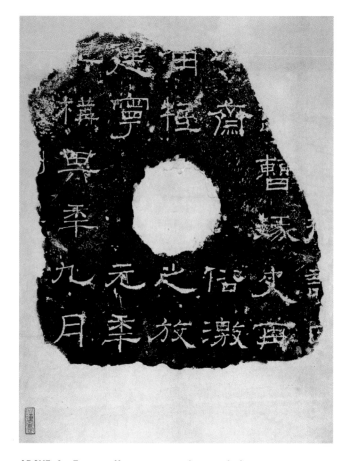

ABOVE: An Eastern Han stone carving, made by a stone mason chiseling over a calligrapher's work.

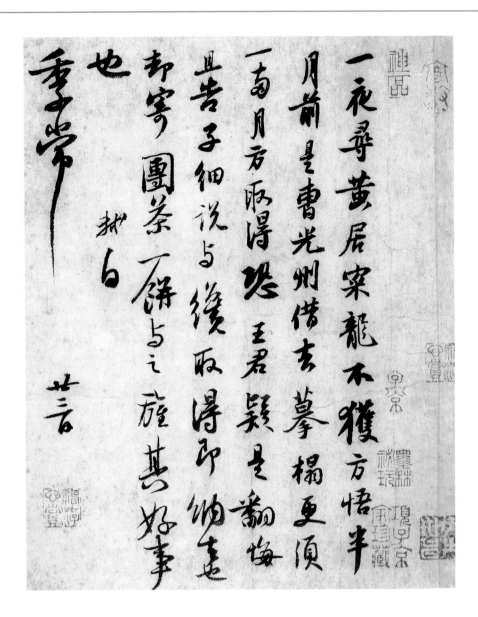

ABOVE: This letter was handwritten in Running script by Su Shi (1036–1101), one of the greatest and most famous intellectuals of the Song dynasty.

During the Shang and Zhou dynasties letters were carved on bronze objects and in the Qin and Han on stone. All together they are known as metal and stone characters. These letters had to be written in calligraphy first before being transferred onto objects by craftsmen. Characters of beauty are noted for their spirit and are called "*chi* of metal and stone," prized for the quality of the form as well as the strength. The second tradition comes from bamboo and wooden strip books, silk hand scroll writing, and, later, the Han dynasty's official record. These writings are made directly onto the surface by the calligraphers, not needing to be re-interpreted by craftsmen. Those features are called the "*chi* of book and scroll." When studying calligraphy it is important to discover this "way of the brush" and the spiritual expression it creates.

Chinese calligraphy has traditionally been divided into four scripts: Zhuan, Han Official (also known as Clerical), Standard, and Running scripts. Each script has a number of different branches and forms. In this book as well as introducing these four scripts, we will also discover the early Pictographic forms to make a total of five scripts, discovering the strokes, structures, and brush techniques of each script, as well as their practical uses in everyday life.

THE FIVE SCRIPTS

PICTOGRAPHIC

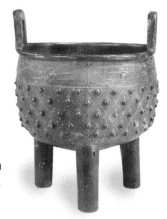

The earliest Pictographic works discovered so far are from the Shang dynasty, carved on tortoise shell and animal bones. The bamboo and wooden strip book may be earlier (its character appears carved on early bones) but examples are still to be found by archaeologists. In the Shang dynasty, bronze objects show how the writing

ABOVE: A bronze, Shang dynasty ding. Although about 3,000 years old, it shows very clear pictographic calligraphy.

developed from the pictographic form towards the earliest Zhuan script. Texts carved on bronze objects either refer to a piece's owner or else a significant record for the state, such as a war. In that time there was little importance placed on the size of the character and the overall composition is very free.

ZHUAN SCRIPT

During the Zhou dynasty (1027–221 BCE) Chinese culture, literature, and philosophy all flourished greatly. The characters used through this period are called the Great Zhuan. They can be seen in many bronze objects as well as the earliest surviving wooden strip books. The calligraphy features very calm and smooth strokes with a tidy balanced structure, with the writing composed on a clear grid.

In 221 BC the Qin emperor united the whole of China. He immediately ordered his prime minister, Li Si (?–208 BCE), to unify the language and characters, creating a simplified and stylized official writing, called Small Zhuan, to supersede all the languages and scripts of the conquered six states. The new writing was taller and more rectangular and each character was made from

ABOVE: Yishan stone inscription carving with calligraphy by the prime minister Li Si, the creator of the Small Zhuan script.

even, smoothly curving strokes. Good Zhuan calligraphy has four qualities: *yun*, the even arrangement of strokes; *yuan*, smooth curves with no sharp lines; *qi*, strict, even spacing; and *zheng*, plumpness of the characters.

ABOVE: A bronze tiger with inlaid gold Zhuan script characters from the Warring States period (475–221 BC) of the Zhou dynasty. Made in two halves, it would be split so that the king had one half, his general the other. Only when the two sides came together could orders be proved to be genuine.

HAN OFFICIAL

This is a simplification of the Zhuan script, developed during the Western Han dynasty (206BCE–CE24). Round edges were squared off and curves became straight. The shape of the characters became wider and shorter. Its clearest feature is the wave stroke, known as the goose tail. Han Official script from this period was the first to show the artistic and personal feelings of the calligrapher. Many different forms of the script have survived, and each calligrapher interpreted his own characteristics onto the script, the most famous being Cai Yong (133–192).

By this time the demands of state, politics and war ensured that an enormous quantity of wooden books and hand scrolls were produced. These writing have many different features: some are very serious and tidy, some are very free and fluent—like floating cloud and flowing water.

ABOVE: A piece of philosophy from the Xi Ping period of the Han dynasty.

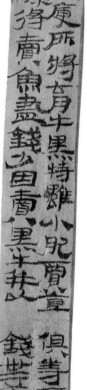

LEFT: This wooden strip book from the Western Han is a military record.

部會逾萬人有

輔塔頂衆盡瞻覩

悅大哉觀佛之光

寸法王禪師謂同

連滄溟非雲羅

STANDARD SCRIPT

Zhong Yao (151–230), who lived during the Eastern Han dynasty, is attributed as the titan of the Standard script. His work was the first step of the long evolution of calligraphy from the Han Official to the Standard. He was followed by Wang Xi Zhi (321–379), respected as the greatest calligrapher in all Chinese history. He did great works in many scripts but his writing shows Standard script at full maturity.

The Sui period (589–618) and Tang dynasties (618–907) are renowned as the golden age of Chinese calligraphy. Over these three hundred years all forms of writing reached their peak, created by a great number of master calligraphers. The most important ones are Ou Yang Xun (557–641), Yu Shi-Nan (558–638), Chu Sui Liang (596–658), Yan Zhen Qing (709–785), and Liu Gong Quan (725–785). Yan Zhen Qing in particular created powerful and dignified works representing the highest Tang features and his influence has lasted to the present day.

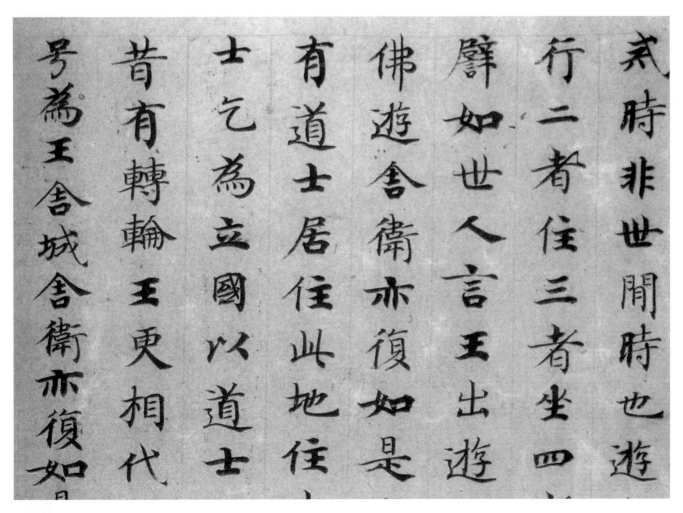

ABOVE: By the Tang dynasty the Standard script had become highly developed, as seen in this Buddhist sutra.
LEFT: Standard script was also used by Yan Zhen Qing in monumental stone carving to record the important history of a Buddhist pagoda.

闢二儀而有像顯

形潛莫覩者見在智猶

挹之莫測其源

若掩色不鏡三千

RUNNING SCRIPT

Running script started to develop even earlier than Standard script, Zhang Zhi (?–CE192) creating it as a simplification of the Han Official. He wrote characters using a single brush stroke, allowing the energy, or *chi*, to flow through the character with the brush stroke. Running script's greatest exponent was Wang Xi Zhi. He recreated the masterpieces of the previous age in his own style—full of freedom, elegance, and sophistication. The *Lan Ting Xu*, a record of an intellectual salon in 345, has become the most famous single piece of Running script calligraphy.

Running script calligraphy in the Tang dynasty also reached a splendid peak. Sun Guo Ting (648–703) wrote *The Theory of Calligraphy* which has been greatly influential ever since, becoming the key for anyone wanting to learn the script. Zhang Xu (7–8th century) and Hua Su (725–785) are two monks who are the most famous running script calligraphers. They created a completely free and expressive style, described by some as "mad" or "crazy" Running script. Both the theory and practice of Chinese calligraphy reached its peak in the Tang dynasty. More than 1,000 years later there continue to be many, many great masters creating extraordinary masterpieces, but none have been able to surpass these early calligraphers.

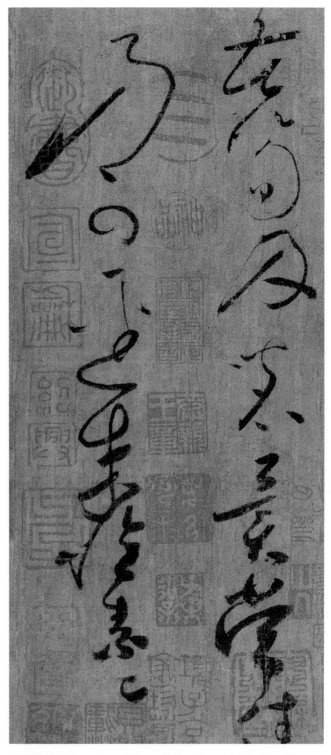

ABOVE: This is a piece of "crazy" Running script by Hua Su, describing his love of the bamboo shoot and the pea.

LEFT: A copy of Wang Xi Zhu's writing by Hui Ren Tang, describing the journey to India of a Tang dynasty emperor's brother in search of the history of Buddhism.

MATERIALS

The Four Treasures

Also described as the "treasures of the studio" and the "lifelong friends of the scholar," these traditional descriptions of the materials emphasize their importance in your artistic explorations and the expression of your ideas. Using the materials to the full will give expression to your calligraphy.

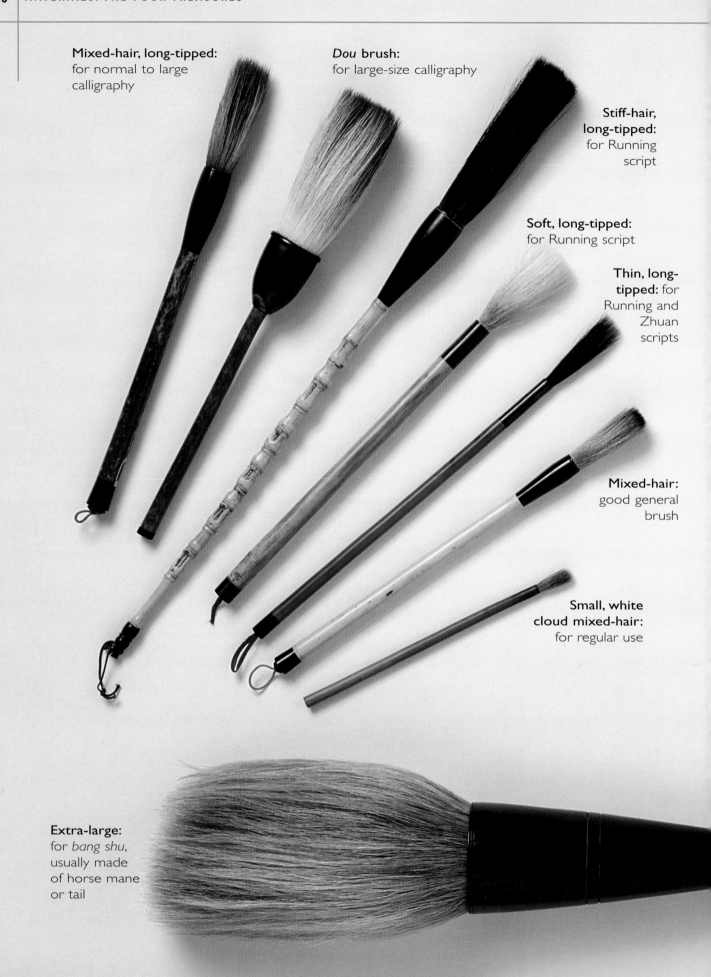

Mixed-hair, long-tipped: for normal to large calligraphy

Dou **brush:** for large-size calligraphy

Stiff-hair, long-tipped: for Running script

Soft, long-tipped: for Running script

Thin, long-tipped: for Running and Zhuan scripts

Mixed-hair: good general brush

Small, white cloud mixed-hair: for regular use

Extra-large: for *bang shu*, usually made of horse mane or tail

Brushes

The brush, the essential tool of the calligrapher, is also an extension of his heart. First used over 5,000 years ago to decorate pots, these early brushes were used until the start of the Chin dynasty (221 BC), when Meng Tian made the first modern brush, selecting hairs and binding them together with bamboo, in the same way as is used today. The brush handle can be made from bamboo, wood, jade, stone, metal, and even porcelain while the tip varies according to use with different animals' hairs being used. Generally there are three types: stiff hair (originally made from the hair of the bear, deer, horse, wolf, or rabbit); soft hair (goat, chicken feather, or first-cut baby hair); and mixtures which combine the two. The size can be as fine as a needle or as large as a broom and the tip can be any length to make different brush effects.

A good brush has four qualities: *jian*, sharpness: the hairs should gather together to make a fine tip; *qi*, evenness: when the brush is dry and open the hairs should be of equal length; *yuan*, roundness: together the hairs are plump and round; *jian*, resilience: the hairs should retain their strength and shape, especially when wet. Always try a brush before you buy, the retailer should provide a sample.

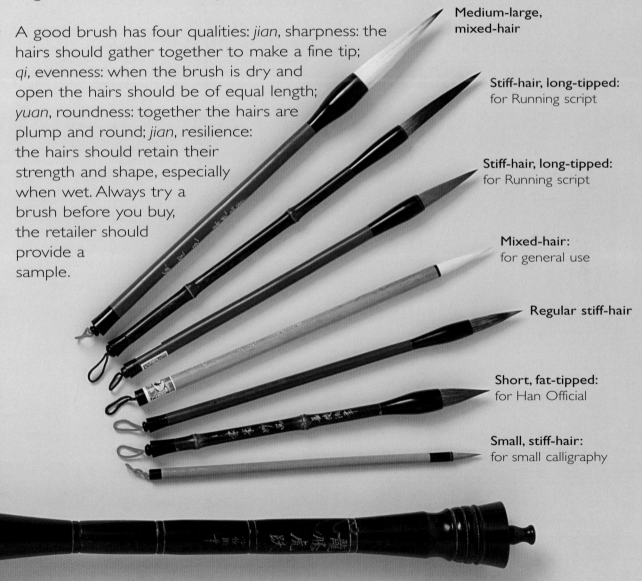

Medium-large, mixed-hair

Stiff-hair, long-tipped: for Running script

Stiff-hair, long-tipped: for Running script

Mixed-hair: for general use

Regular stiff-hair

Short, fat-tipped: for Han Official

Small, stiff-hair: for small calligraphy

Ink

The history of ink corresponds with that of the brush. At first, the ancient Chinese used two pieces of stone to grind down graphite or charcoal—in the same way that today we grind colored pigments—to mix with water and glue. The ink stick, first used around 2,000 years ago, is made of soot, glue, and more than ten different types of herb, mixed and pounded together in hard wooden carved molds. It is ground directly onto an ink stone with a few drops of water. The ink stick can be made from the soot of plant or animal oil or the soot of pine wood and resin: oil soot makes a warm, shiny black, while pine soot makes a cold, matte black. Different color pigments can also be used to make colored ink sticks. During its long history, the ink stick has become a work of art in itself, being collected and given as gifts to scholars or friends. Nowadays, the quality of pre-prepared liquid ink has improved and it is especially convenient for large calligraphy.

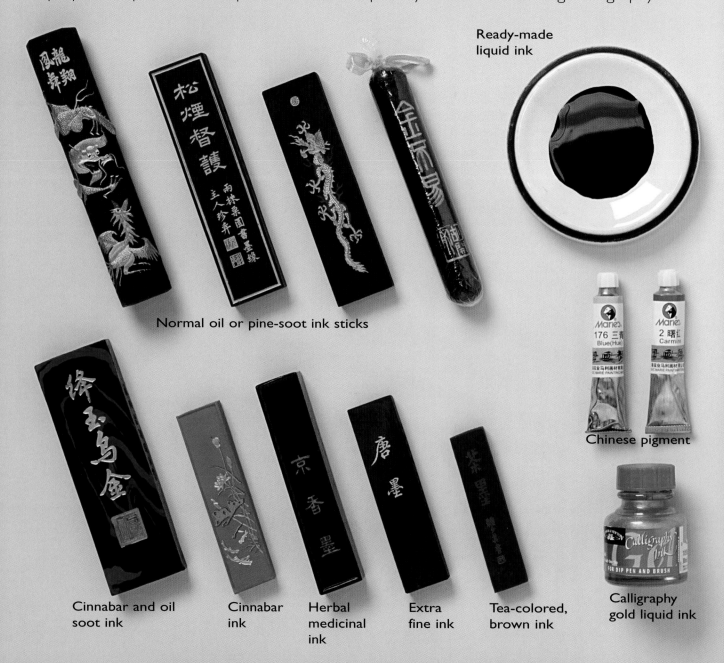

Ready-made liquid ink

Normal oil or pine-soot ink sticks

Chinese pigment

Cinnabar and oil soot ink

Cinnabar ink

Herbal medicinal ink

Extra fine ink

Tea-colored, brown ink

Calligraphy gold liquid ink

When using liquid ink only decant as much ink as you think is needed: unused ink should never be returned to the bottle as it will smell. Avoid placing ink sticks in either direct sunshine or dampness. After you have ground the ink, immediately dry the tip on a tissue: otherwise it will begin to crack.

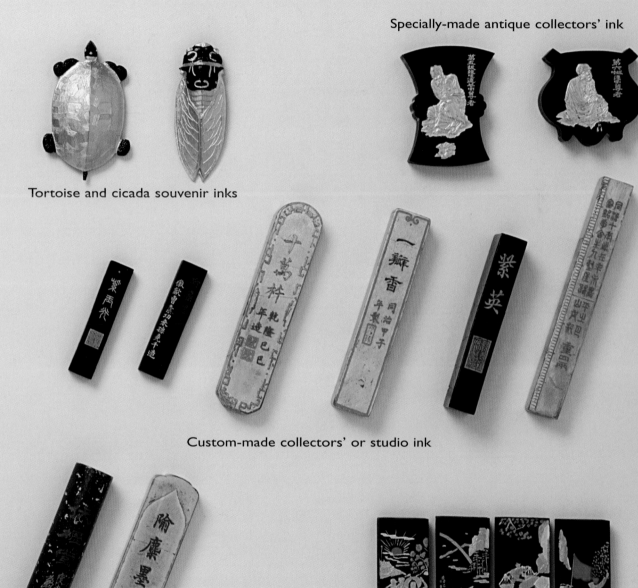

Specially-made antique collectors' ink

Tortoise and cicada souvenir inks

Custom-made collectors' or studio ink

Custom-made collectors' or studio ink

Cultural Revolution period ink set

Ink Stones

Because an ink stone will remain with the calligrapher for his whole life, throughout history the Chinese intellectual has taken great trouble when choosing and maintaining his stone, searching for the smoothest, most beautiful stone.

To judge a good ink stone ensure that it is solid and smooth, though the best stone is relatively soft, it must produce fine ink and not damage brush hair. The most famous ink

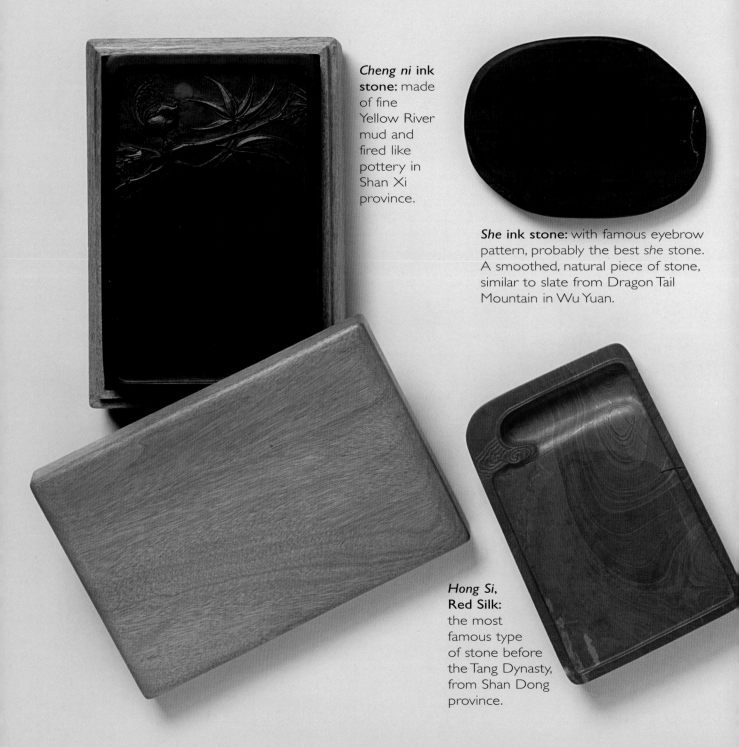

Cheng ni **ink stone:** made of fine Yellow River mud and fired like pottery in Shan Xi province.

She **ink stone:** with famous eyebrow pattern, probably the best *she* stone. A smoothed, natural piece of stone, similar to slate from Dragon Tail Mountain in Wu Yuan.

Hong Si, **Red Silk:** the most famous type of stone before the Tang Dynasty, from Shan Dong province.

stones are *duan* stones from Canton province, *she* stones from Jiang Xi and An Hui provinces, *tao* stones from Gan Su province, and *cheng yi* stones from Shan Xi. Famous ink stones also include the red silk, one of the many *hong si* stones, from Shan Dong province. Other materials such as jade, metals, or lacquered wood are also used but natural stone is the best. Apart from grinding ink, a good ink stone should be a work of art in itself: beautifully designed, rich with carving, and protected by a wooden box.

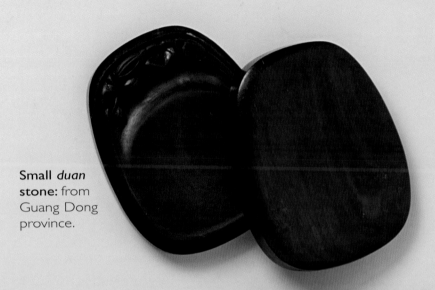

Small *duan* stone: from Guang Dong province.

Tao ink stone: special green stone from Gan Su province.

Duan ink stone: slightly red in color with a sought-after, fire-burned mark in the bottom right corner.

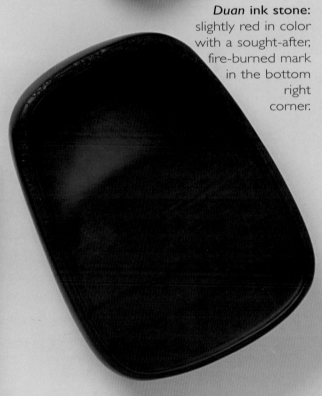

Chinese *xuan* paper: available in various colors and sometimes splashed with gold or silver flakes, *xuan* paper comes in various sizes, all in the same 1:2 format, from 3ft to 12ft long. The paper is usually made from sandalwood or mulberry bark.

Ready-made couplet paper: printed with a pattern to show the position for each character.

Ready-made fan: simple white or gold-flaked, with a dark edging of silk.

Pine wood board: either cover with matte latex paint first or write directly onto the wood.

Paper

Paper was invented in China, and the ancient Chinese Xuan region was the center of paper making. Made using sandalwood or mulberry bark as the main fiber, though hemp and bamboo can also be used, Chinese paper is either sized (treated and non-absorbent), unsized (absorbent or raw), or semi-sized, and in every shape and style depending on need. For beginner's practice, go for the cheapest *yuan shu* or *mao bian* paper,, sometimes erroneously named grass paper, but in fact made from bamboo. Alternatively, you could work with old newspaper!

Hardback album

Traditional note paper: specially made from folded single sheets, each part-patterned.

Thread-bound butterfly book: home-made, can be used for showing seal collections.

Celebration paper: red, hand-painted paper for greeting messages.

Book printing paper: always has a swallow-tail mark in the center for folding.

Yuan shu **paper:** made from bamboo fiber, this is the most popular paper to practice calligraphy.

Fabric

Letter paper: for correspondence.

盍　然　為　亦

昌　在　其　粟

冊　林　棄　唯

丘　年　好　壽

　　古　風　常

　　之　給　此

TECHNIQUES

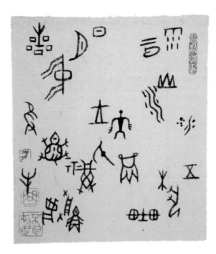

Mastering the Five Scripts

"In a journey of a thousand miles, start
with the first step"
The first step toward successful Chinese
calligraphy is your brush technique, so master the
brush stroke by stroke, step by step. As Liu Gong
Quan, the great Tang dynasty calligrapher, said,
"A sincere mind makes a perfect brush." Only
with this knowledge can we enjoy our journey
into calligraphy.

Preparing the Table

Traditional Chinese calligraphy is written vertically and from right to left. As most people are right-handed, the desk top should be prepared with the ink stone and ink stick at the top right. The brush washer should be beside them, all within comfortable reach. After grinding the ink remove the ink stick from the ink stone: dry it and place it beside the stone. Brushes should also be placed on the right-hand side, the paper and paperweight in the middle, all resting on a piece of felt or blanket. The sample of the masterpiece being copied sits on the left-hand side so that it can be easily studied while you are grinding ink. The desk top should be kept tidy and clear, with space in front of you so that long pieces of paper can be moved up and away when producing large pieces of calligraphy. Clear away any unnecessary items, including teacups!

Manuscript sample

Spare paper

Blanket or felt: soft, non-absorbent backing.

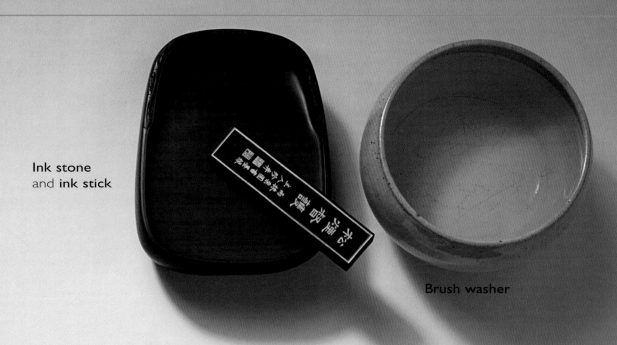

Ink stone
and ink stick

Brush washer

Paperweight

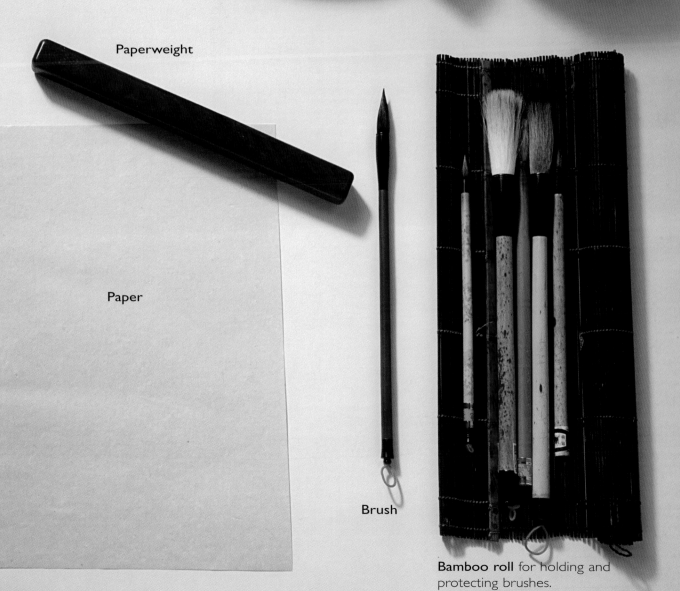

Paper

Brush

Bamboo roll for holding and
protecting brushes.

Holding the Brush

When writing calligraphy it is important to hold the brush in the correct way, even though in the very beginning it might feel uncomfortable. Over a thousand years of practice, Chinese calligraphers have developed the best way to hold the brush that allows it to lift up and press down in every direction with the least strain on the tip, while also allowing the brush to rotate through the fingers all the time. Sit upright, keeping the spine straight, adjusting the wrist to the correct angle to keep the brush straight to the surface of the paper. When writing extra-large calligraphy remember to use the whole body strength.

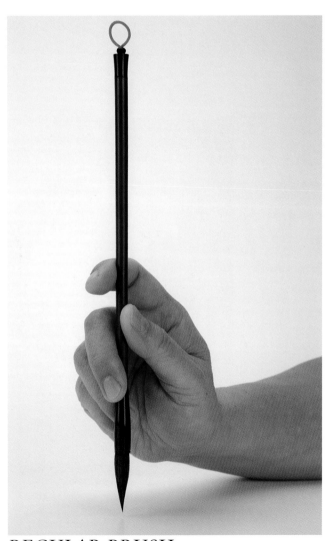

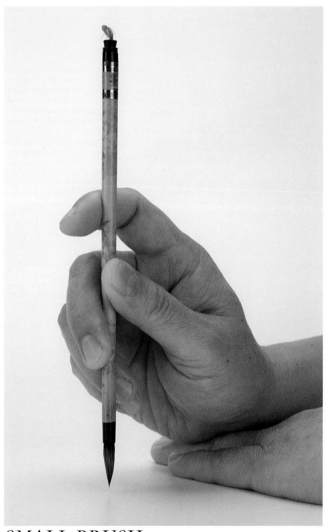

REGULAR BRUSH

With normal characters of 1–2in. size use this position. Hold the brush with the thumb, index and middle fingers, letting it move in every direction and rotate easily, with the last two fingers pressing against the back stabilizing the brush.

SMALL BRUSH

When writing very small calligraphy with characters up to 1in. high, rest the wrist of the writing hand on the back of the other hand to make sure the brush is stable.

LARGE BRUSH

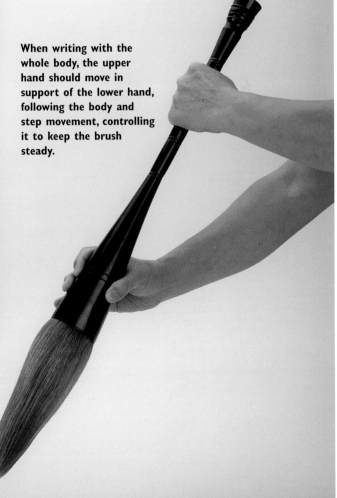

To write large calligraphy it is advisable to stand up and hold the brush higher up the shaft. Adjust the angle of the wrist to keep the brush straight to the paper. In this position the elbow and shoulder are also involved in the brush movement, not just the fingers.

When writing with the whole body, the upper hand should move in support of the lower hand, following the body and step movement, controlling it to keep the brush steady.

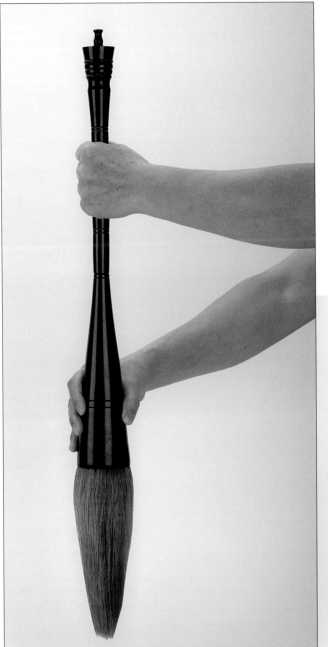

EXTRA-LARGE BRUSH

Use both hands as well as the whole body. The right hand holds the base of the brush and does most of the movement. The left hand holds the upper part of the brush to support and stabilize the brush.

Pictographic Script

The origins of Chinese writing can be found in the Pictographic script. The ancient Chinese used the script to carve religious texts foretelling the future onto tortoise shell and animal bone, the character-covered bones now known as oracle bones. Used around 4,000 years ago, so far around 5,000 individual characters have been found, about half of which are readable. Archaeological research indicates that the characters were first written with a brush before being carved. After carving the characters were then filled with black, brown, or red color to make them clear.

ABOVE: An oracle bone made from an ox's shoulder, carved around 4,000 years ago.

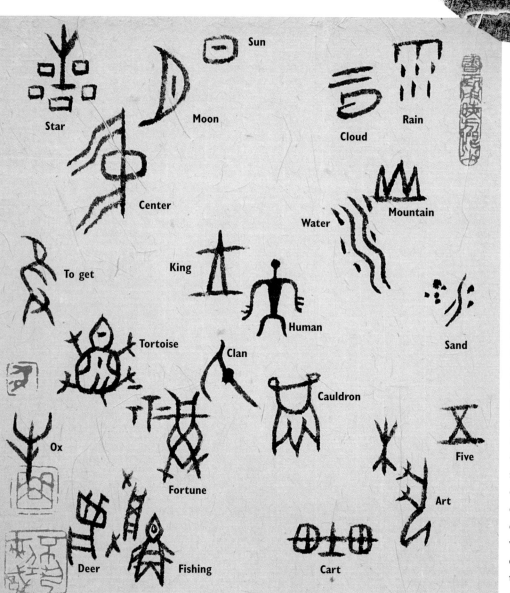

Star
Sun
Moon
Cloud
Rain
Center
Water
Mountain
To get
King
Human
Sand
Tortoise
Clan
Cauldron
Ox
Five
Fortune
Art
Deer
Fishing
Cart

LEFT: Samples of pictographic characters. Easy to learn and use, some are direct descriptions of natural shapes, such as "mountain," "moon," or "tortoise." Others evolved to show a meaning, such as "center" and "fishing." This calligraphy script is very artistic and relatively free. The lines do not need to be straight and the letters can be of any size, big or small; the characters can also be reversed with no loss of meaning or even be placed on their side or upside down.

BRUSH TECHNIQUE

The strokes of the Pictographic script are very simple. Only two types are used: straight and bent lines. The short line is the dot, the long line can be horizontal, vertical, or diagonal. With different connections, the curved stroke, either combined into circles or with straight lines, can be made up into many different forms. Hold the brush like a knife or chisel, feeling like it is cutting into the paper rather than drawing smoothly on its surface.

HORIZONTAL STROKE

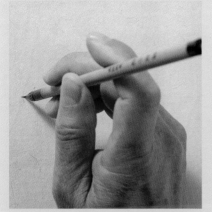

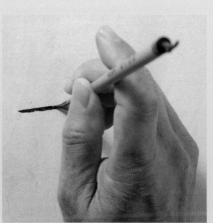

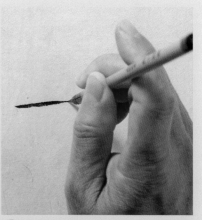

3 Carefully control the end of the stroke, lifting the brush away from the paper with care.

1 The tip of the brush is just like the tip of a knife. Place it directly and firmly onto the paper.

2 Move the brush slowly in a series of movements rather than a smooth line, like a series of connected dots.

CURVED STROKE

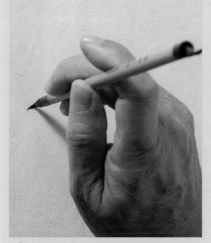

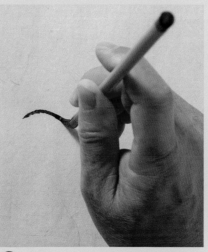

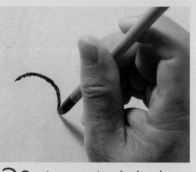

3 Continue rotating the brush until the very end of the stroke.

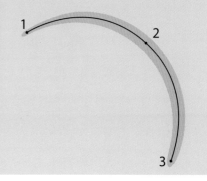

1 The brush starts just like a simple dot: place it at the start of the stroke with precision, giving it a sharp point.

2 When the brush stroke starts curving the brush should rotate slightly between the fingers. Make sure the tip of the brush remains in the center of the stroke.

STRUCTURE OF PICTOGRAPHIC CHARACTERS

Even though this ancient script is very free, certain rules do need to be followed to make the characters look good. Always ensure that the characters are well-balanced and symmetrical when necessary.

SYMMETRICAL CHARACTERS

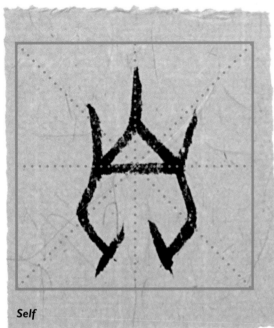

Self

Ancient people drew a nose to describe themselves. There are many symmetrical characters, so remember to make them balanced.

PARALLEL LINES

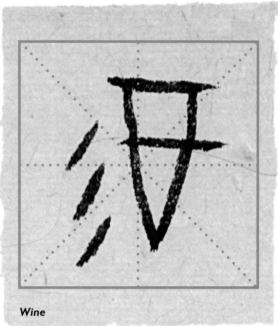

Wine

This character combines a vase on the right with three drops of liquid on the left. When strokes are repeated they should be parallel to each other.

PARALLEL CURVED LINES

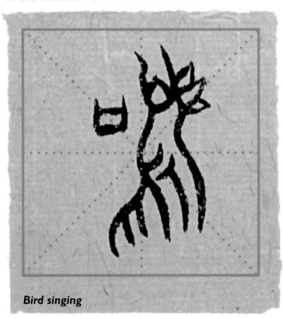

Bird singing

The right-hand side shows a bird. From the neck down to the wings and claws there are groups of parallel curved lines. Make each stroke clear.

CONTRAST AND BALANCE

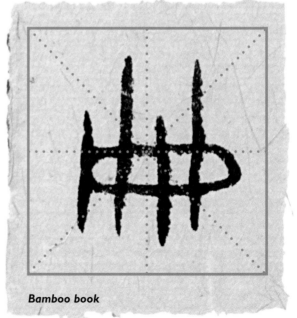

Bamboo book

The vertical lines represent bamboo strips bound together, so make them all slightly different lengths and the horizontal lines very slightly curved.

PICTOGRAPHIC STROKES AND SAMPLES

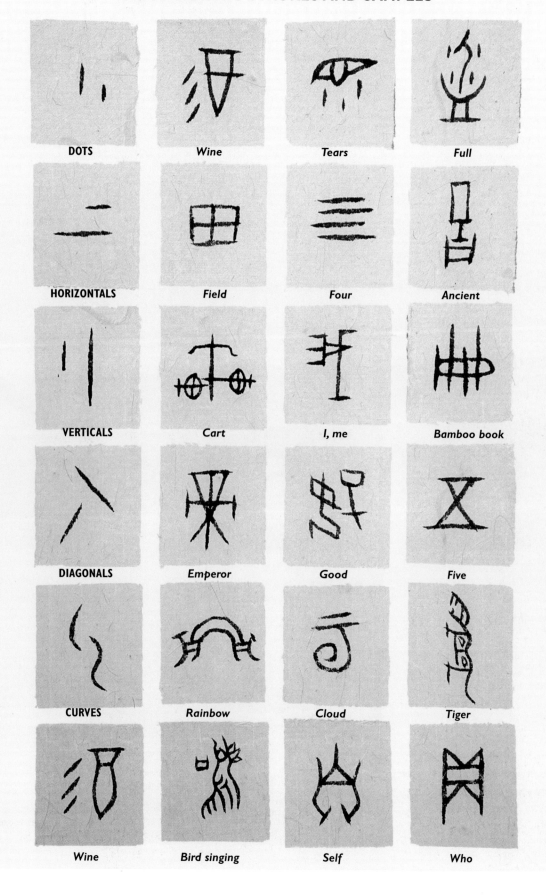

DOTS	*Wine*	*Tears*	*Full*
HORIZONTALS	*Field*	*Four*	*Ancient*
VERTICALS	*Cart*	*I, me*	*Bamboo book*
DIAGONALS	*Emperor*	*Good*	*Five*
CURVES	*Rainbow*	*Cloud*	*Tiger*
Wine	*Bird singing*	*Self*	*Who*

Zhuan Script

Zhuan script is very important to the history of ancient Chinese manuscripts, as it is placed right in the middle of the progression from pictographic to modern stylized scripts. The most famous versions are "Great Zhuan," written in the Western Zhou dynasty (9th century BCE), and "Small Zhuan," which was first seen in 221 BCE.

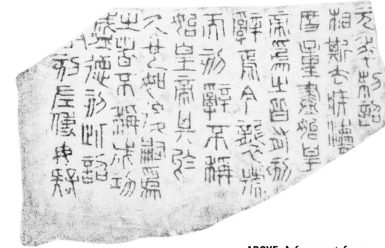

ABOVE: A fragment from Qin dynasty government records of 221 BCE.

BRUSH TECHNIQUE

Zhuan script characters should be upright, level, and straight. Practicing just the dot and smooth stroke will give you these skills. Make curved strokes by smoothly rotating the brush in your fingers—but never turn your wrist.

VERTICAL STROKE

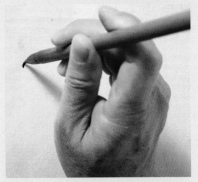

1 Touch the paper with the brush tip pointing downward—the opposite way to the intended stroke.

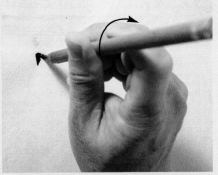

2 Use your fingers and thumb to rotate the brush on itself until the tip is ready to move straight down.

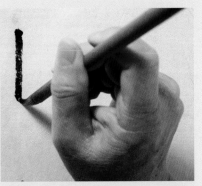

3 Press down onto the paper and use your arm to pull the brush towards you, keeping the brush tip in the centre of the stroke.

4 Reaching the end of the stroke, rotate the brush on itself counterclockwise—the opposite way to the start of the stroke. Hiding the tip in the ink, move back up the stroke while lifting the brush smoothly away from the paper.

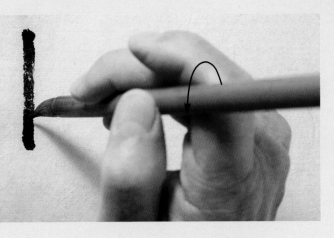

RETURN STROKE

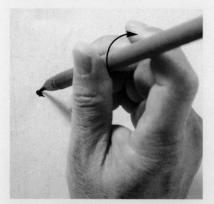

1 | To make curved and return strokes—when two separate strokes join to make up a single curve—move the brush smoothly and at an even speed. Point the brush in the wrong direction and turn the tip clockwise to follow the intended line of the stroke.

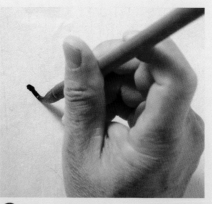

2 Make the curve by continuing to turn the brush with your fingers, always keeping the tip in the center of the stroke.

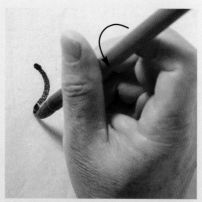

3 To make the opposite curve, spin the brush back through your fingers in a counterclockwise direction.

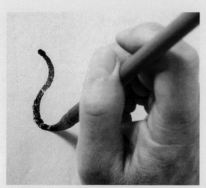

4 Stop when you reach your full twist at the bottom.

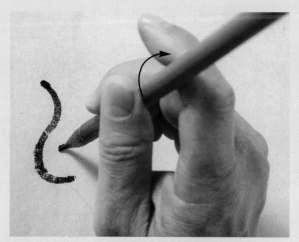

5 Lift the brush and start the return curve, moving downward to meet the first stroke, again rotating the brush to ensure that the tip remains in the center of the stroke.

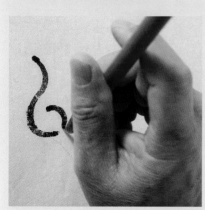

6 Continue over the end of the previous stroke, using the same pressure to make a perfect match.

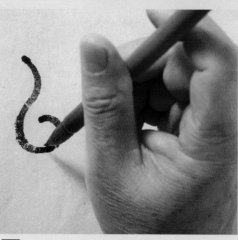

7 Finish by gently lifting the brush away. Practise until you can make the join smooth and almost invisible.

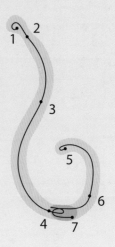

STRUCTURE OF ZHUAN CHARACTERS

Before you use a character, practise writing it on a grid like the ones below. This will help you become familiar with each character's composition and how to keep them in proportion to one another.

SYMMETRICAL CHARACTERS

Periphery

Each character should be well balanced. If there are more than two similar strokes in one character keep them parallel to each other.

OPEN CHARACTERS

Square

Sometimes a character is not exactly rectangular or straight. Make sure that it is well-centred and stable, balancing left and right.

SIMPLE CHARACTERS

Down

Make characters with few strokes slightly smaller and keep the distance between strokes arranged comfortably so that visually they balance with more complicated characters.

COMPLICATED CHARACTERS

Look

Before you write, calculate and arrange in your mind the distance between strokes, making sure the strokes are spaced evenly. Give the lower part relatively more space.

ZHUAN SCRIPT STROKES AND SAMPLES

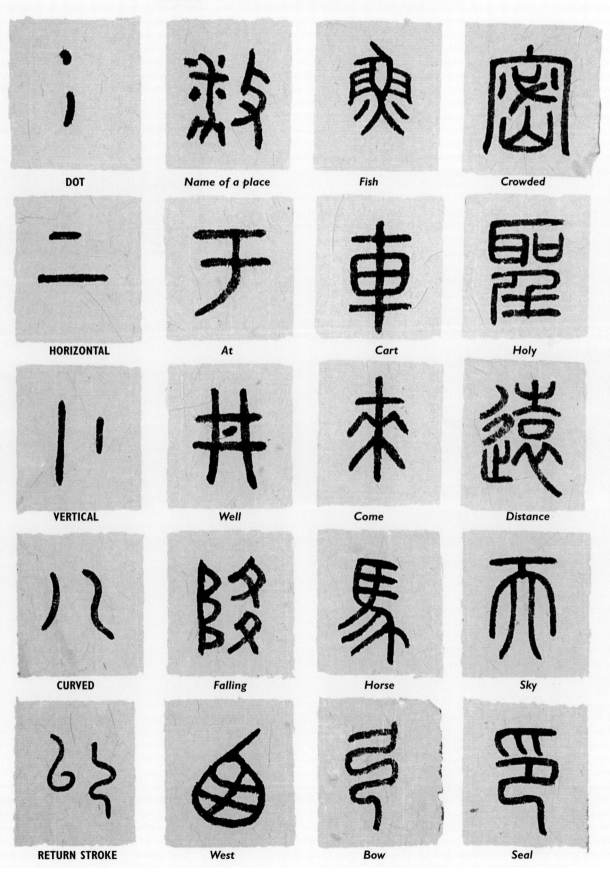

DOT	*Name of a place*	*Fish*	*Crowded*
HORIZONTAL	*At*	*Cart*	*Holy*
VERTICAL	*Well*	*Come*	*Distance*
CURVED	*Falling*	*Horse*	*Sky*
RETURN STROKE	*West*	*Bow*	*Seal*

Han Official Script

This script matured and became popular during the Han dynasty (206BCE–CE220). Its clearest feature is its wave stroke which shows how the use of the brush had changed: as well as moving in every direction it is also lifted up and pressed down during writing. The most famous stroke is the Silkworm Head and Goose Tail. As this script was used to write the bamboo or wood strip books the characters are even and straight, though some extended strokes show its visual beauty.

BRUSH TECHNIQUE

Han Official strokes are made in every direction, so the brush must rotate easily within the fingers. The tip of the brush, though, should always remain in the center of the stroke.

ABOVE: Early wood strip books show how the Han Official script combined flowing lines of characters within a rigid structure.

LONG VERTICAL STROKE

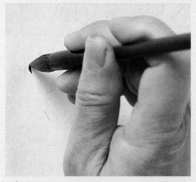

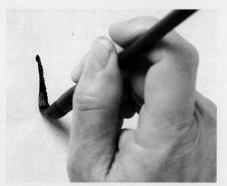

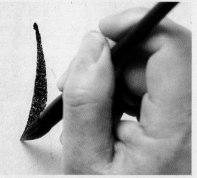

1 Start by "hiding the tip:" at the top move the brush slightly upward before pressing down into the main stroke.

2 As the brush moves down, gently and gradually press it onto the paper.

3 Press down hardest roughly two-thirds of the way through the stroke before gradually lifting the brush away again.

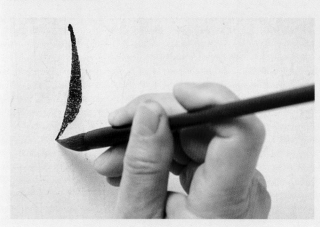

4 End with care, making a fine, sharp point. Sometimes this stroke can be exaggerated to add an extra dimension to the calligraphy.

HOOK STROKE

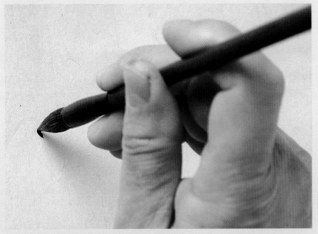

1 At the beginning, start moving the brush tip in the opposite direction to the stroke.

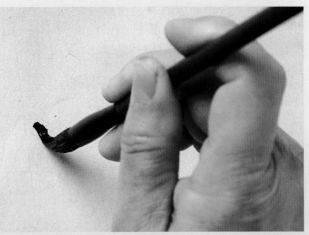

2 To "hide the tip" move back down into the main stroke over the initial mark.

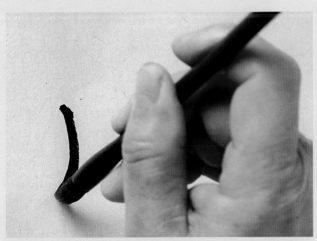

3 Move the brush slowly downward and get ready to change direction.

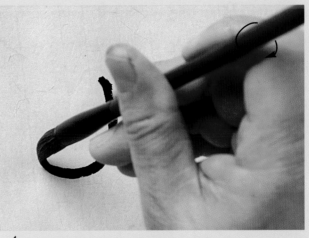

4 Now with the brush moving in a different direction, the shaft should be rotated to keep the tip in the center.

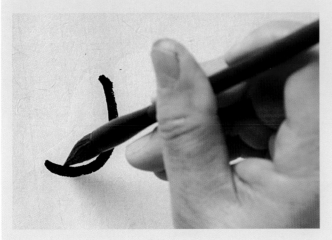

5 By the end of the stroke, the tip should be brought back over the line to hide the end inside.

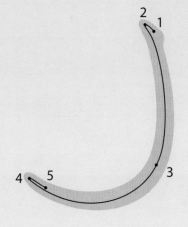

SILKWORM HEAD HORIZONTAL STROKE

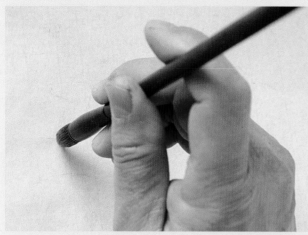

1 The brush starts towards the left, also pressing slightly downward.

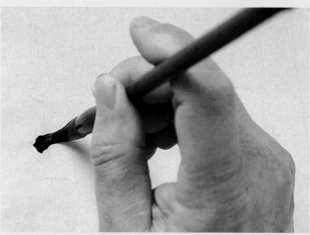

2 Immediately bend the tip back on itself so that the brush can move to the right, hiding the start of the stroke and making the silkworm head.

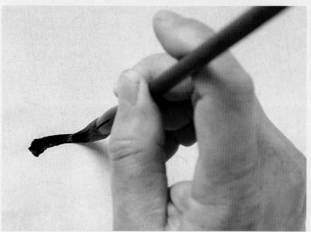

3 Move the brush very slightly upward as you move it toward the right.

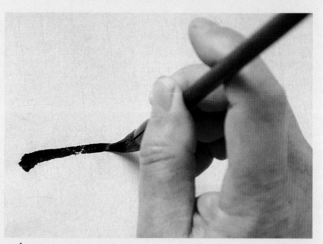

4 When the brush reaches the end of the stroke, don't rush to lift it away.

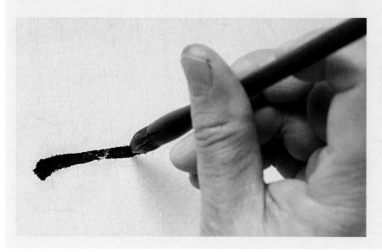

5 Rotate the brush clockwise and move the tip left, back into the stroke, before lifting it away from the paper.

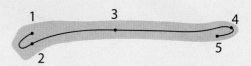

SILKWORM HEAD AND GOOSE TAIL STROKE

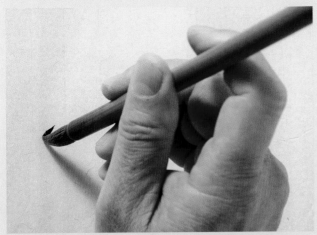

1 Start with the brush heading down to the left, just as with the horizontal stroke.

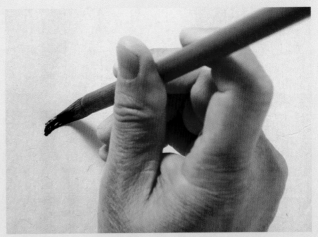

2 Bend the tip back on itself and move it slightly upward to create the silkworm head.

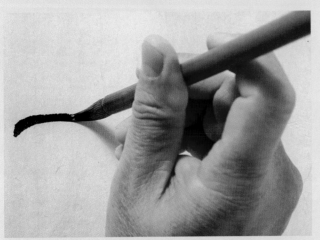

3 While the brush moves to the right, create a slight wave by moving it in an upward curve.

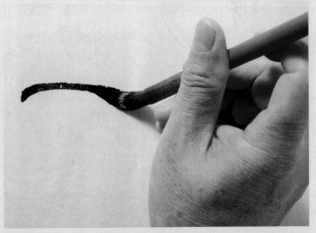

4 Before the end of the stroke the brush gradually presses heavily down, widening the line but keeping the top line relatively flat.

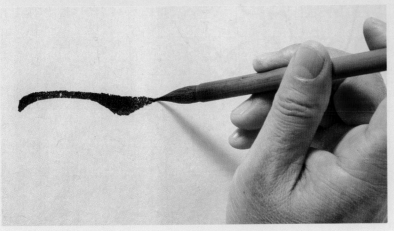

5 Slightly rotate the brush counterclockwise as it is gradually lifted up to leave a finely pointed goose tail.

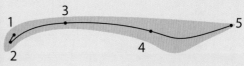

STRUCTURE OF HAN OFFICIAL CHARACTERS

The structure of the Han Official script characters are generally shorter and wider than Zhuan characters. The strokes are dense and even, though one of a character's main strokes can be exaggerated.

SYMMETRICAL CHARACTERS

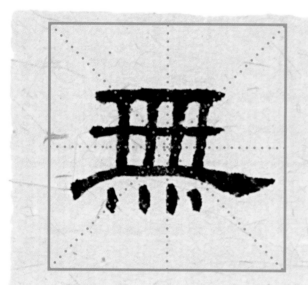

Nothing

The four vertical lines are very evenly arranged and the four dots relate directly to each of these strokes. The top two horizontal strokes are also parallel but the third is exaggerated to end in a large goose tail.

OPEN CHARACTERS

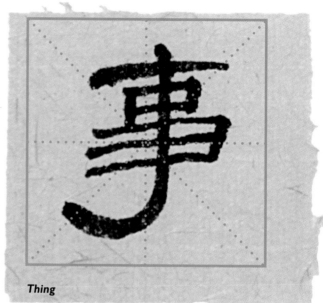

Thing

Pack the horizontal strokes densely, allowing space for the last major stroke to be exaggerated but ensure the weight of the character is balanced.

HAN OFFICIAL SCRIPT STROKES AND SAMPLES

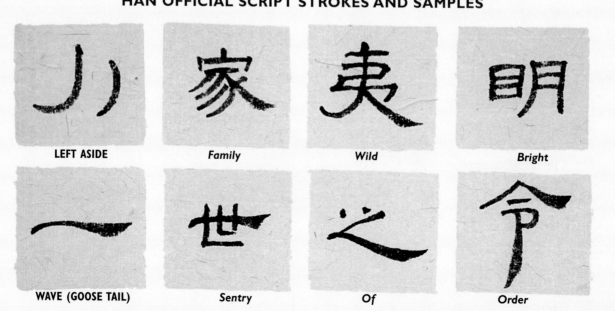

LEFT ASIDE | *Family* | *Wild* | *Bright*

WAVE (GOOSE TAIL) | *Sentry* | *Of* | *Order*

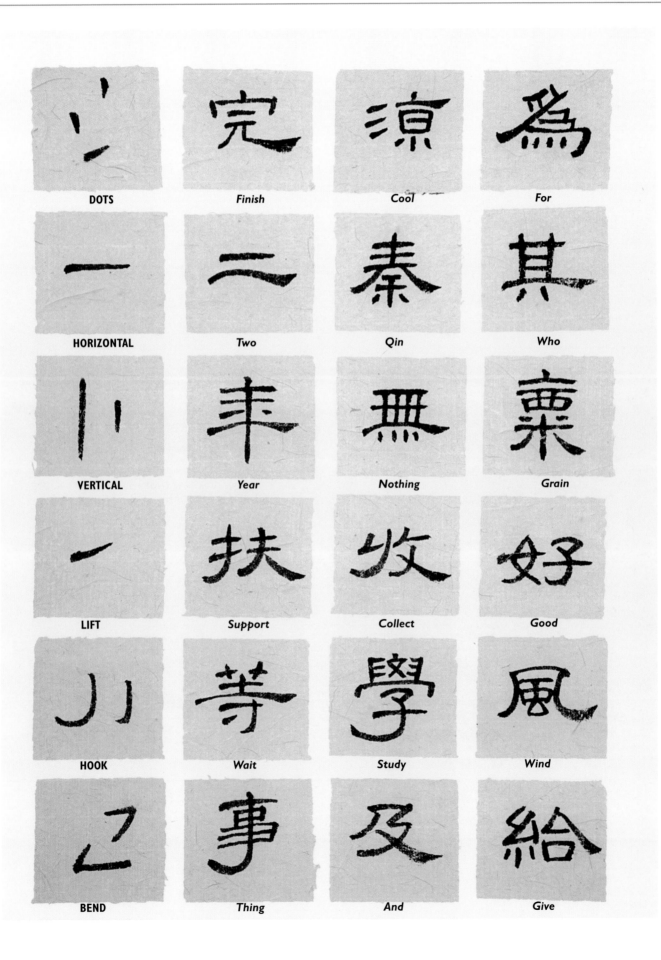

DOTS	*Finish*	*Cool*	*For*
HORIZONTAL	*Two*	*Qin*	*Who*
VERTICAL	*Year*	*Nothing*	*Grain*
LIFT	*Support*	*Collect*	*Good*
HOOK	*Wait*	*Study*	*Wind*
BEND	*Thing*	*And*	*Give*

Standard Script

Standard script is the most widely used script in Chinese writing. From the Eastern Han period (CE25–220) to the present day it has now been in use for nearly 2,000 years. It developed from the Han Official script, changing the wave to a slice and adding hook and sharp tick strokes. By the Western Jin period (3rd–4th century CE) Zhong Yao and Wang Xi Zhi had created the rules of the Standard script, finally separating it from the Han Official. Reaching its golden age in the Tang dynasty (618–907), the masterpieces of this period remain studied to this day.

BRUSH TECHNIQUE

Liu Gong Quan (778–865) famously said that a sincere mind made an upright stroke, so the brush should follow our mind. The rules of the Standard script are also important so keep your mind calm, concentrate, and hold the brush properly to allow you to create all types of brush stroke.

HORIZONTAL STROKE

1 Move the tip up to the left before bending it down in the opposite direction almost immediately, rotating counterclockwise.

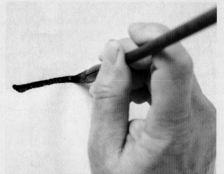

2 Bring the brush upward a little bit, then smoothly and firmly take it toward the right.

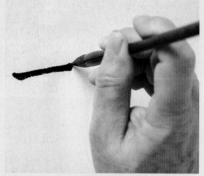

3 As you reach the end of the stroke, lift the brush tip up toward the right.

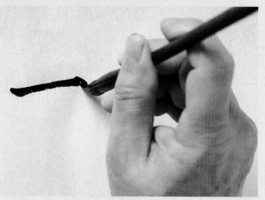

4 Turn the brush tip and press the brush down firmly to the bottom right.

5 Rotate the brush clockwise, hiding the tip in the stroke.

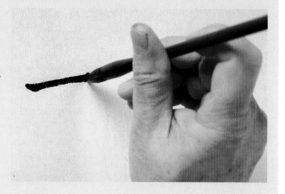

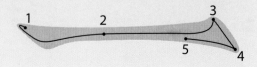

PAIR OF DOTS

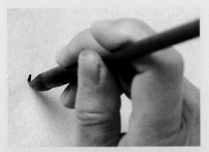

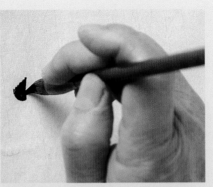

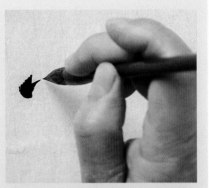

1 Begin with the left-hand dot, pressing the brush downward to the left.

2 Rotate the brush counterclockwise, keeping the tip in the center of the dot.

3 Move the brush up to the right, lifting the brush away, leaving a mark like a bird dropping his head.

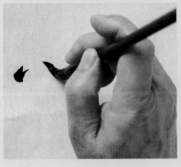

4 Continue to move the brush in a smooth line, dropping it back on the paper for the right-hand dot.

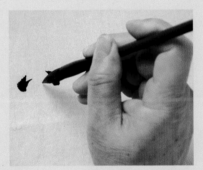

5 Rotate the brush clockwise, lifting up toward the left. The two dots should resemble two birds talking.

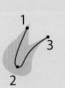
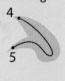

SLICE STROKE

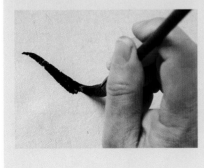

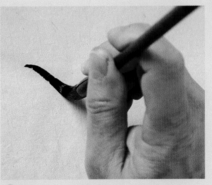

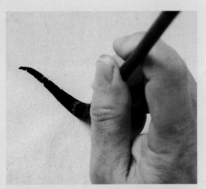

1 Gently touch the brush on the paper to start, pressing slightly horizontally.

2 Change direction to move the brush downward to the right, gradually adding pressure.

3 Carry on adding pressure until the brush reaches the bottom of the stroke.

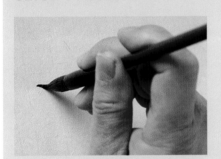

4 Rotate the brush as you reach the bottom of the stroke and begin to lift it away.

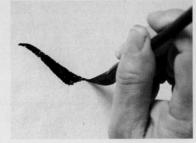

5 Gradually lift the brush, controlling the tip as it reaches the end of the stroke.

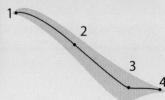

BEND AND HOOK STROKE

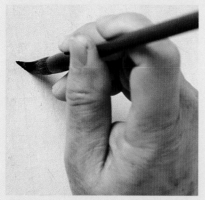

1 Begin like the horizontal stroke, rotate counterclockwise before moving away to the right.

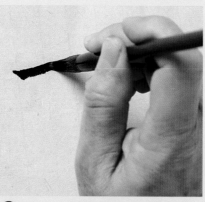

2 Move the brush firmly and smoothly toward the right.

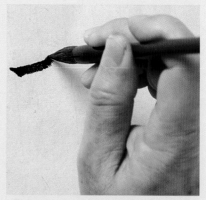

3 Reaching the end, the brush tip should move right up to the top corner.

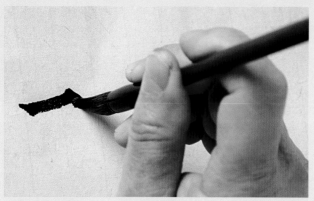

4 Press the brush down firmly to create the strong bent shoulder.

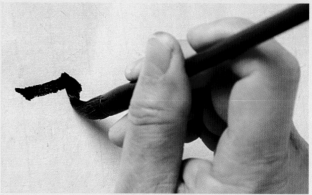

5 Slightly rotate the brush clockwise as you take the brush down into the vertical, keeping the tip in the center of the stroke.

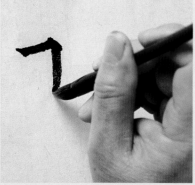

6 Move smoothly downward to complete the bend stroke.

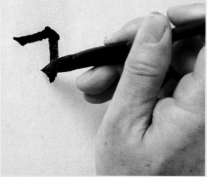

7 Take the brush upward to the left before lifting it away from the paper to make the hook.

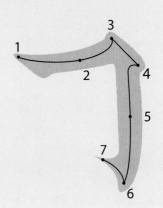

THE SEQUENCE OF STANDARD SCRIPT STROKES

Standard script characters can have anything from one to twenty strokes. However, if we follow the correct sequence we will be able to make them up properly. Generally characters are built up from top to bottom and from left to right.

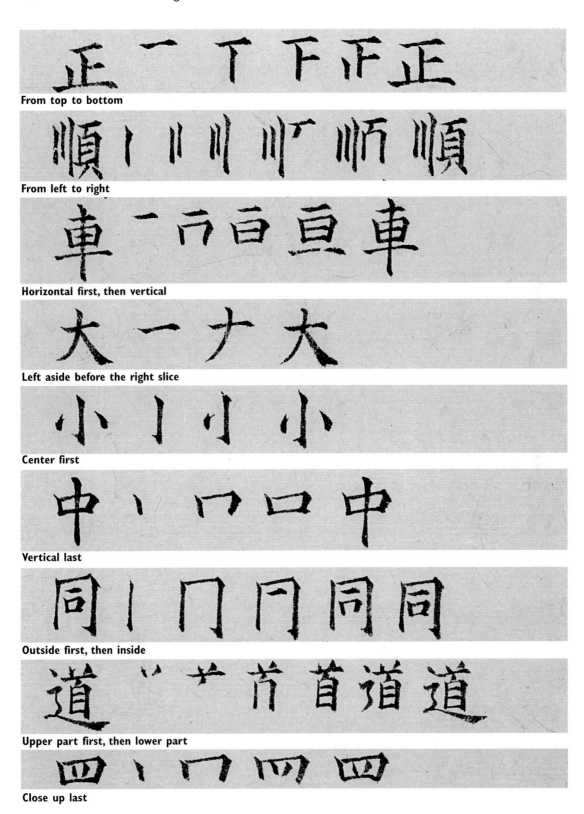

From top to bottom

From left to right

Horizontal first, then vertical

Left aside before the right slice

Center first

Vertical last

Outside first, then inside

Upper part first, then lower part

Close up last

STANDARD SCRIPT STROKES AND SAMPLES

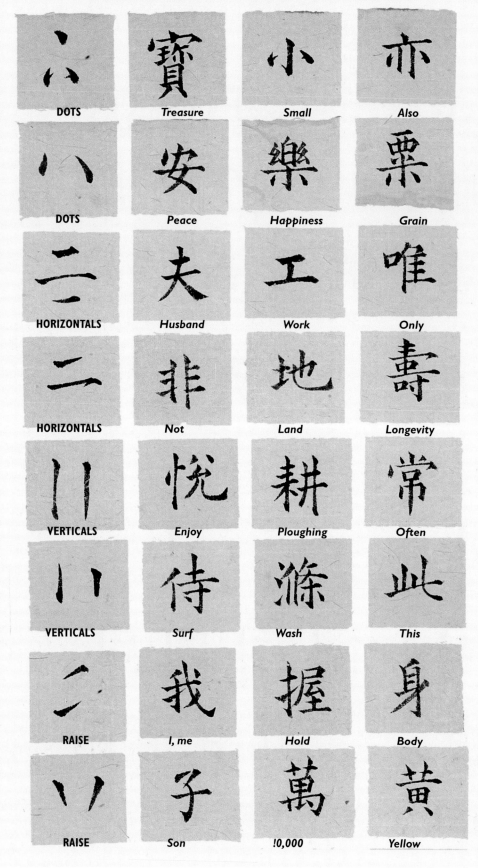

DOTS	*Treasure*	*Small*	*Also*
DOTS	*Peace*	*Happiness*	*Grain*
HORIZONTALS	*Husband*	*Work*	*Only*
HORIZONTALS	*Not*	*Land*	*Longevity*
VERTICALS	*Enjoy*	*Ploughing*	*Often*
VERTICALS	*Surf*	*Wash*	*This*
RAISE	*I, me*	*Hold*	*Body*
RAISE	*Son*	*!0,000*	*Yellow*

HOOKS	*East*	*Universe*	*Drink*
HOOKS	*Think*	*City*	*Phoenix*
BENDS	*For*	*Book*	*Extension*
BENDS	*Start*	*Out*	*Black*
LEFT ASIDE	*Name*	*Room*	*At*
LEFT ASIDE	*History*	*Stability*	*Salty*
SLICES	*Spring*	*Change*	*Gold*
SLICES	*Luck*	*Of*	*Food*

Running Script

Running script is a quicker and more free version of Standard script. Linking the strokes together allows the spirit, or *chi*, to move from one character to the next, like floating clouds and flowing water, and it is now the most popular and practical script. The strokes also combine roundness with the squareness typical of Standard script characters. Wang Xi Zhi (321–397) is recognized as the greatest Running script calligrapher, and his masterpiece, *Lan Ting Xu*, has been studied by calligraphers ever since. Through the golden period of calligraphy during the Tang dynasty, this script was used to express more freely the calligraphers' internal feelings.

BRUSH TECHNIQUE

All the stroke rules are the same as Standard script. The difference is that strokes are not made one by one but instead are linked up—sometimes a single, continual stroke will be used to create a whole character. Remember that all strokes should compliment each other and the continuous flow of *chi* must always be the prime consideration.

THREE DOTS

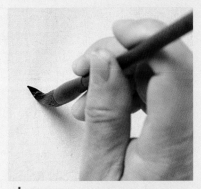

1 | This is a radical—a part character—meaning "water." Start at the top pressing the brush down firmly.

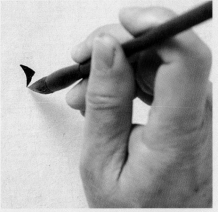

2 | Lift the brush up moving the tip immediately in the direction of the second dot.

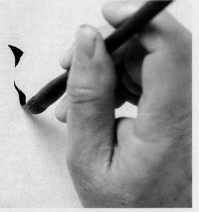

3 | Start the second dot with a curve that continues the stroke from the first dot. Even though the stroke is broken, the *chi* continues.

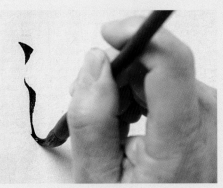

4 | Lift the brush slightly between the second and third dots but do not let the tip leave the paper.

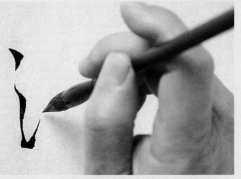

5 | Rotate the brush a little counterclockwise and lift the brush upward, moving straight toward the next character.

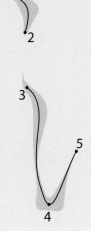

FOUR DOTS

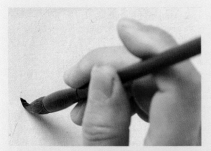

1 Press down and give a slight counterclockwise rotation.

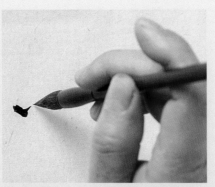

2 Lift the brush up and to the right, toward the position of the second dot.

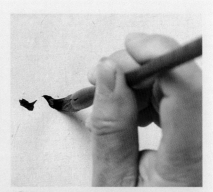

3 Press down to make the second dot while rotating clockwise.

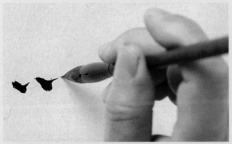

4 Rotating back counterclockwise, lift the brush up toward the position of the third dot.

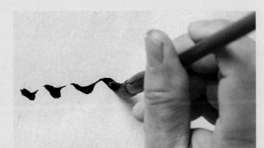

5 Link the third and fourth dots using the same movement.

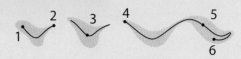

HOOK STROKE

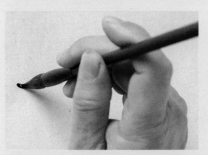

1 This is a horizontal hook. Start by placing the brush tip firmly onto the paper.

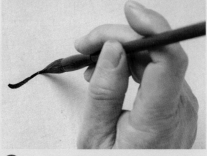

2 Lift the brush up the paper a little as you move to the right so that the stroke is given movement.

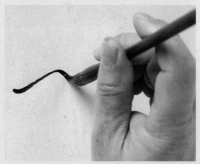

3 Press the brush downward with a slightly clockwise rotation.

4 Continue rotating clockwise, moving leftward, making the stroke rounder than the sharp Standard stroke.

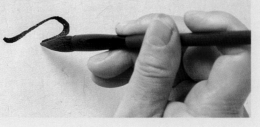

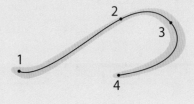

RUNNING SCRIPT STROKES AND SAMPLES

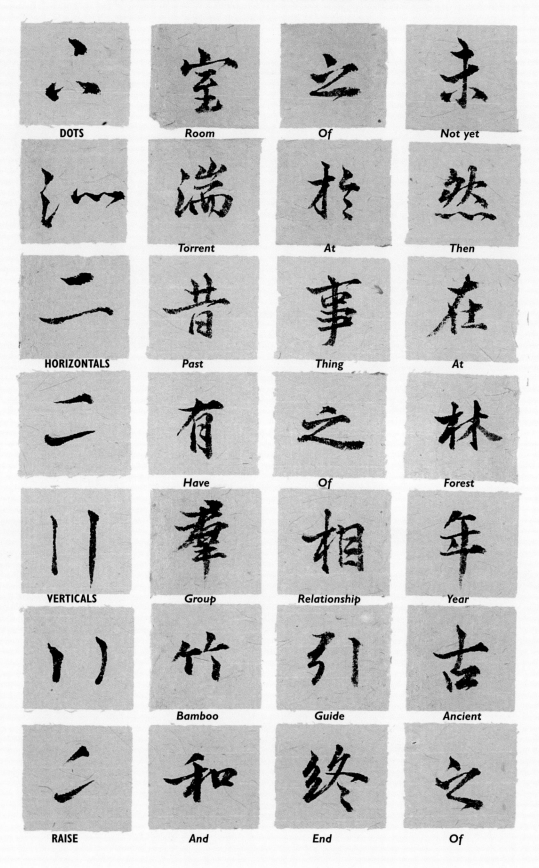

DOTS	Room	Of	Not yet
	Torrent	At	Then
HORIZONTALS	Past	Thing	At
	Have	Of	Forest
VERTICALS	Group	Relationship	Year
	Bamboo	Guide	Ancient
RAISE	And	End	Of

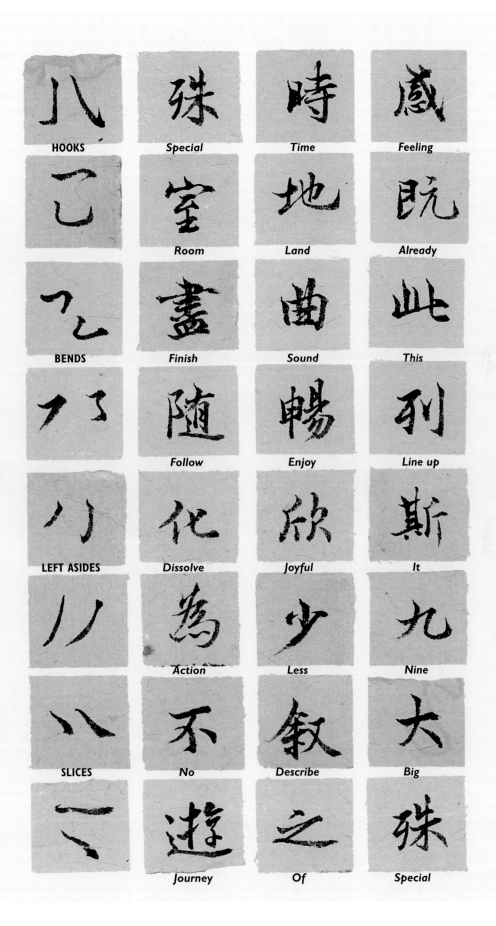

八	殊	時	感
HOOKS	*Special*	*Time*	*Feeling*
乙	室	地	阮
	Room	*Land*	*Already*
乙	盡	曲	此
BENDS	*Finish*	*Sound*	*This*
刀	隨	暢	列
	Follow	*Enjoy*	*Line up*
八	化	欣	斯
LEFT ASIDES	*Dissolve*	*Joyful*	*It*
八	為	少	九
	Action	*Less*	*Nine*
八	不	叙	大
SLICES	*No*	*Describe*	*Big*
丶	遊	之	殊
	Journey	*Of*	*Special*

Character Comparison

The following pairs of Standard and Running script characters show how the different versions are based on the same basic rules. The Standard script (left) must be written stroke by stroke, the Running script (right) must consider the relationship and brush movement between the various strokes, sometimes reducing the number of strokes, sometimes linking them. Most importantly, the *chi*—or energy—must continue unbroken.

FLOWING

Comparing these characters shows how the Running script (right) links up the dots on the left. The last three Running script strokes are also related closely to each other.

SILK

In the Standard style (left) both halves are the same, though the right-hand side is slightly larger, but in the Running script the whole left-hand side is linked together.

EXTREME

This Standard script character combines three different parts but in the Running script you can see that the brush movement links them up to be made in a continuous stroke.

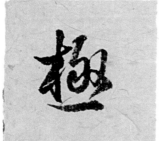

ACTION

The four dots of the Standard script character (left) are transformed into a single horizontal line in the Running script character.

IN ORDER TO

Although the gap between the two parts of the Running script character is retained, they are more clearly linked together by the movement of the brush between the two halves.

BE

The top part of the Running script (right) uses far fewer strokes than the Standard character and is linked directly to the bottom half of the character.

THEN

Apart from all the strokes being linked up in the Running script, at the end of the last dot the brush tip naturally moves downward so the upper dot stroke of the Standard character is missed out.

STRING

Both sides of the Running script character are linked up separately, especially on the right where the final dot is elongated and becomes a link to whatever character follows beneath.

ALTHOUGH

This is another example showing the convenience of continuous writing, missing out a dot stroke from the left-hand side.

OUTSIDE

The dot halfway down the vertical in Standard script becomes a lift in the Running script because it is the link to the first stroke of the other half of the character.

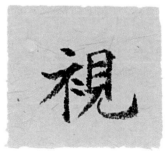 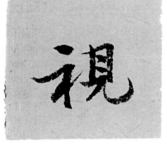

VISION

To achieve flowing Running script, miss out the two central dots and relate the two sides directly with one another.

OF

The solid, sharp angles between the three lines of the Standard script character are linked up and made rounder to make a more flowing Running script character.

STANDARD SCRIPT

Character Build-up

These two characters—"writing" and "the way"—together mean calligraphy. The first character is an up-down type, the second is a left-right type. For the Standard script the pair should combine to be well

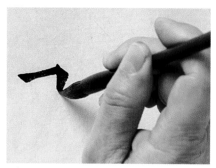

1 At the first bend ensure the shoulder is solid and strong.

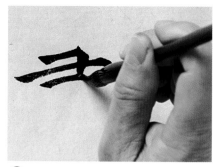

2 The second stroke is relatively long. As the whole character is quite tall it must balance the whole composition.

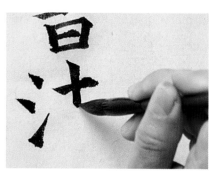

3 After a number of horizontal strokes, make the central vertical stroke the spine of the character.

4 Underneath, begin with three sides of the frame before adding the inside and closing it up.

5 The second character's left-hand side should occupy one-third of the space.

6 Begin the right-hand side with the horizontal and vertical strokes, followed by a long horizontal.

7 To complete the bottom bend, make a diagonal to the left before lifting the brush and pressing down to the right to make a strong elbow.

8 The final dot will stabilize the whole character, so deliberately make it longer and more solid than usual.

centered and stable. When writing the Running script characters you also have to consider the linking strokes and ensure the brush moves cleanly between the various parts of the character.

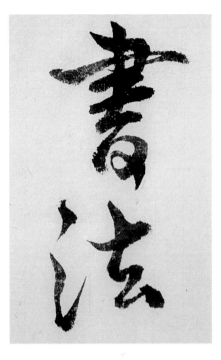

RUNNING SCRIPT

1 The first bend is not as solid as the Standard script.

2 The long horizontal is linked directly to the short horizontal beneath.

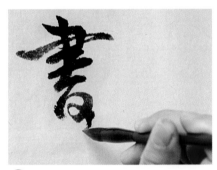

3 The vertical stroke links to the other horizontals and continues to the bottom part of the character.

4 The bottom square changes into a circle and one stroke beneath is missed out as the brush moves directly to the second character.

5 Link the three dots together as shown in the Techniques section (see p.50).

6 The vertical and horizontal are also linked without the brush leaving the paper.

7 The long horizontal stroke becomes short and directly links to the bending elbow.

8 Press the brush down to make the final dot.

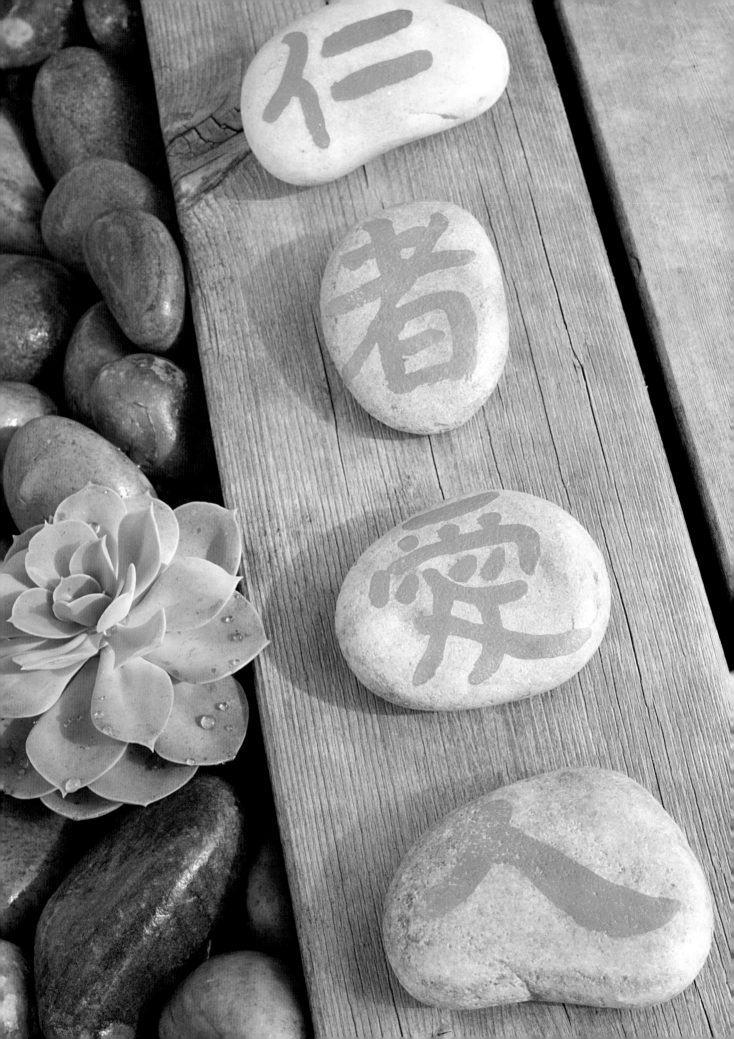

PROJECTS

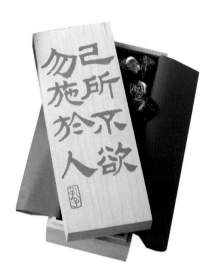

Creating Art with Calligraphy

Calligraphy can be a part of our everyday lives,
even if it is just a simple note, an excerpt from a
diary, or a brief letter to a friend—all become
part of a scholar's life. If we can incorporate
beautiful calligraphy into our lives, we will be able
to benefit both artistically and spiritually.

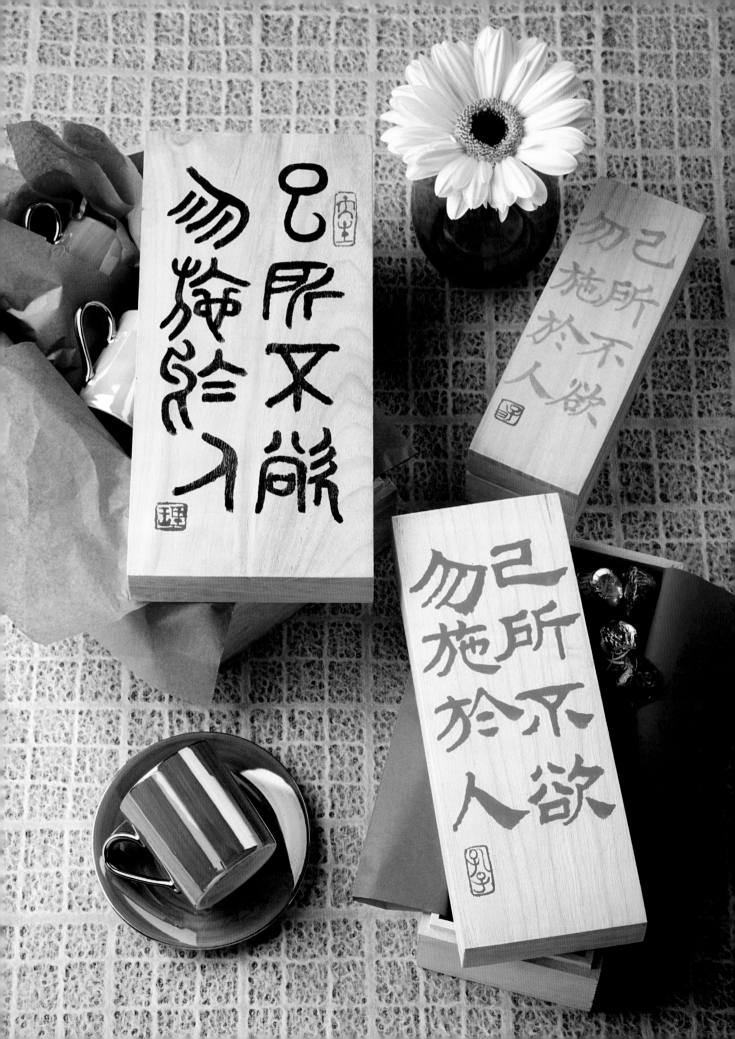

Gift Boxes

Whatever script you use, it should pass on a message. These gift boxes bear Confucius's philosophy "Never give to others something you do not desire yourself," which ensures the message and object are ideally suited. The literal translation of the individual characters is "Yourself things not desire do not give to others." As Confucius lived during the Zhou dynasty, I used the contemporary script, the Great Zhuan, then Han Official and Standard

MATERIALS

- Plain box
- Water-based varnish
- Mixed-hair brush
- Stiff-hair calligraphy brush
- Black ink
- Mineral green pigment
- Calligraphy gold paint
- Fine brush for seal
- Red paint

GREAT ZHUAN SCRIPT

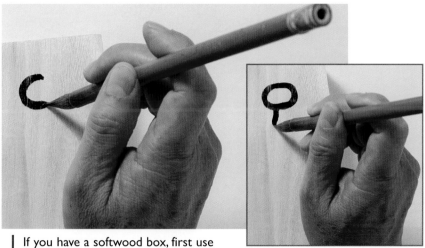

1 If you have a softwood box, first use water-based varnish to seal it, to stop the ink spreading. Carefully plan out the composition, deciding on the size and position of the characters before beginning in the top right corner of the box, using a mixed-hair brush.

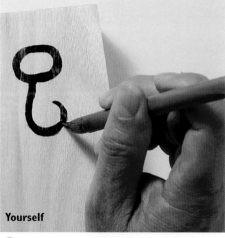

Yourself

2 Finish the first character, *ji*, with a return stroke, joining up at the bottom of the vertical.

TIPS
- Practise the calligraphy on paper before working on the box.
- Use some books as an armrest so that your arm lies parallel with the surface of the box.
- Calculate the number of characters and the space each will use, leaving extra space at the top and bottom.
- If you want to varnish the box afterward, wait until the paint is completely dry.

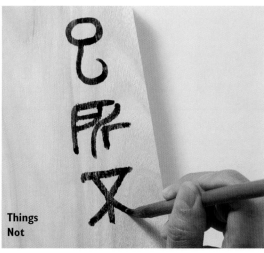

Things
Not

3 Continue down the first column keeping the characters, *suo* (thing) and *bu*, evenly spaced and of similar size, whatever their complexity.

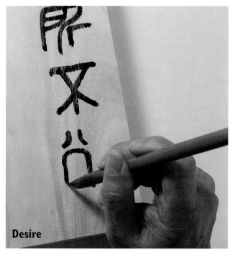

Desire

4 Finish the first column with the character *yu*.

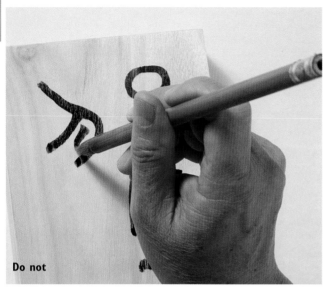

Do not

5 Build up the character *wu* with long, curved strokes. Even though no part of the character is level or straight it must still balance, so do the long strokes first before adding the short strokes.

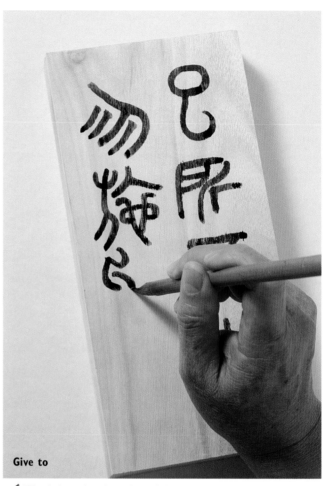

Give to

6 The left and right sides of the second character, *shi*, meaning "give," should balance. Also, check the space around the third character, also pronounced *yu*.

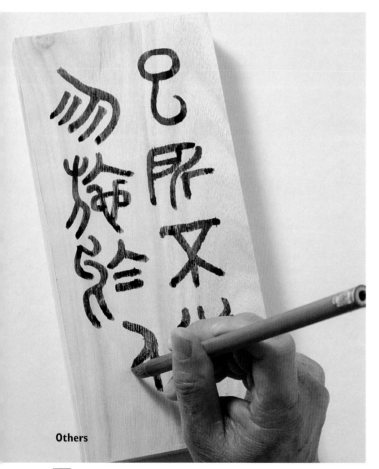

Others

7 The last character, "others," only has two strokes, so make the previous two characters slightly lower and bigger so that the whole composition is balanced.

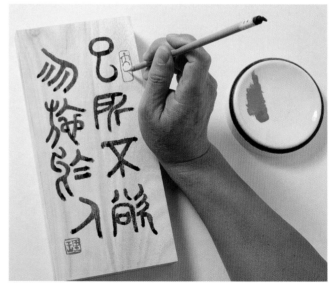

8 Use red paint to draw a seal at the end as the stamping seal will not work on softwood. Stabilize the composition with a delicate Commencing Seal in the opposite corner.

HAN OFFICIAL SCRIPT

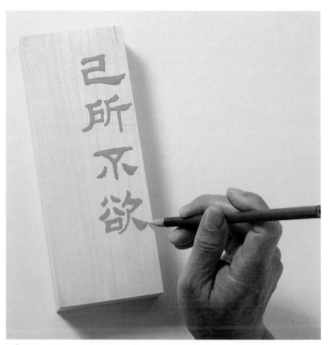

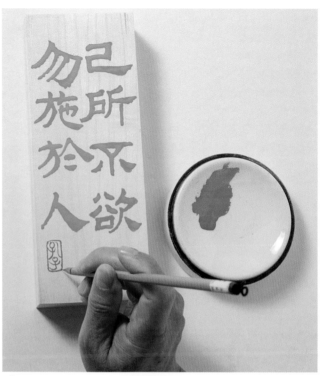

1 The Han Official script is wider and shorter than the Zhuan so ensure that the positioning of each character allows for this difference in size.

2 More space will be available underneath so make the design of the seal taller to fit more comfortably into the space.

STANDARD SCRIPT

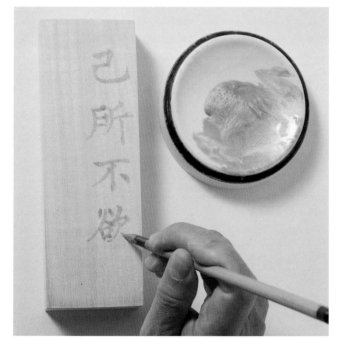

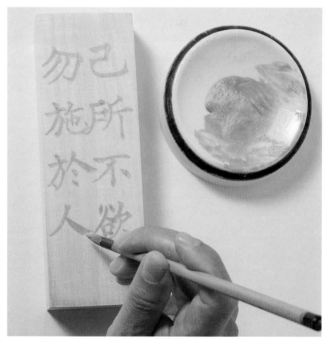

1 Standard script characters occupy identical square spaces, however many brush strokes are used, so give each one its own individual space.

2 When the writing is dry, cover the box with a layer of varnish if you want it to last for a long time.

New Year Door Sign

For thousands of years, all across China, people have used door signs to celebrate every occasion, from important birthdays to the passing of exams, and in particular, New Year. The color red signifies celebration, as seen in this New Year sign. In some areas of China this new year message is fixed upside down because in the Chinese language "upside down" and "arrive" have the same pronunciation, so as a play on words it emphasizes that good fortune is arriving. For an adult's birthday, use "long life" and for a wedding, paint the double happiness character.

MATERIALS

- Red paper, cut as a square and positioned in a diamond
- Large, mixed-hair brush
- Black ink

STANDARD SCRIPT

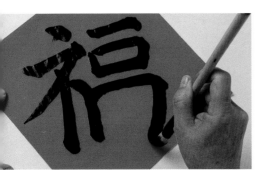

1 Cut the paper into a square and position it on your drawing board as a diamond, holding it with your left hand to keep it stable. The character for happiness/fortune is a two-part character so begin with the left side and build up from the top dot, followed by a left sweep.

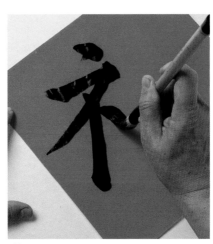

2 The third stroke is a vertical followed by a dot to the right.

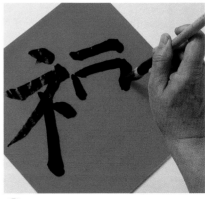

3 The right-hand side also starts at the top with a horizontal stroke. Always start the rectangle underneath with the short, left vertical, followed by a horizontal bending down into the short, right-hand vertical.

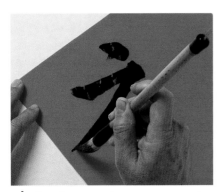

4 Close the box with a horizontal stroke. Repeat the pattern for the larger rectangle below.

5 With three sides of the box complete add the cross inside, writing the horizontal stroke first, then the vertical.

6 Finally, close the box with the bottom horizontal.

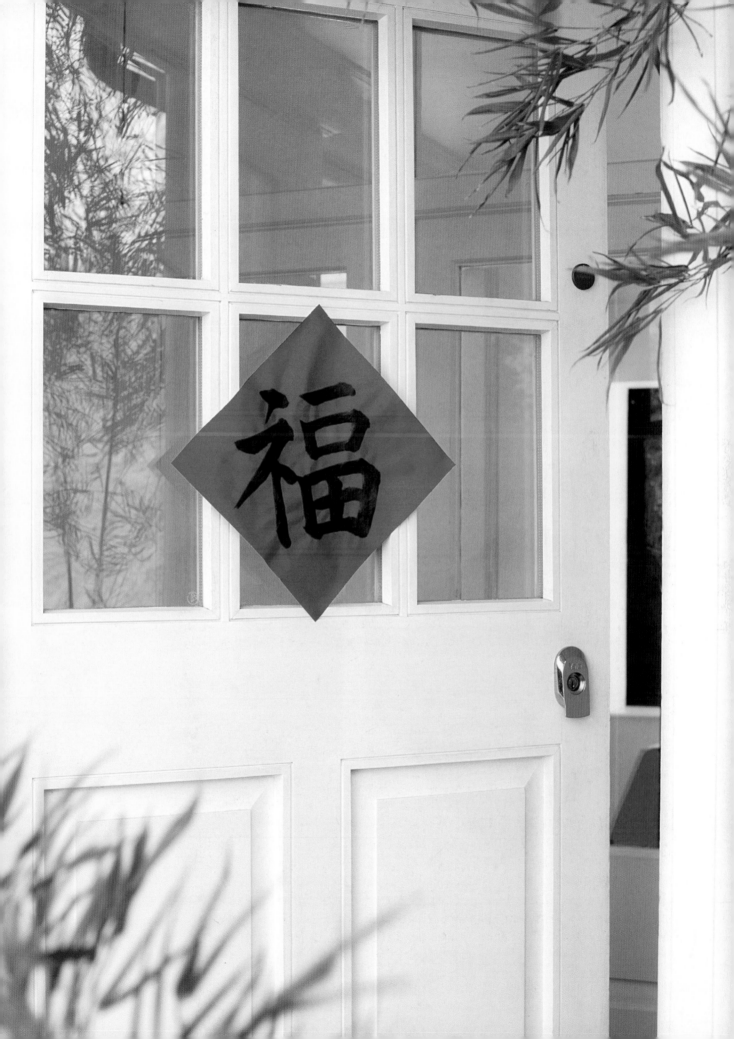

HAN SCRIPT

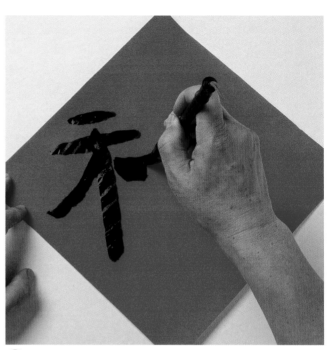

1 Ensure the left-hand side occupies slightly less than half the paper. Make the vertical strong and clear.

2 Han script horizontals are silkworm heads and the dots should be much heavier than in the Standard script.

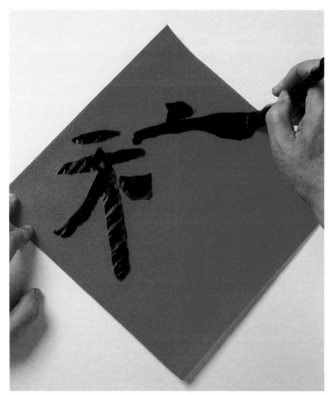

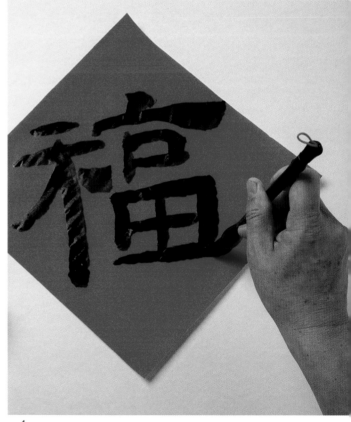

3 On the right-hand side write the dot first. One large main stroke is written as a goose tail. Start with a silkworm head, the brush moving slightly up and to the right before pressing down hard. Finally lift the brush up toward the top of the stroke in a waving motion.

4 Underneath, the large box is solid to stabilize the character. Make three sides of the frame first before adding the cross inside and closing with a horizontal.

ZHUAN SCRIPT

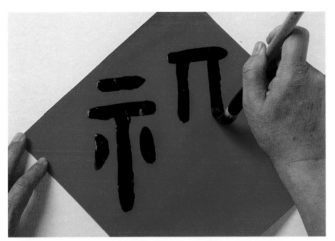

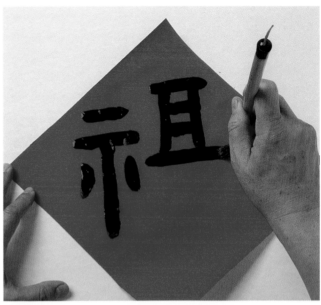

1 With the Zhuan script, the characters are generally slightly more vertical and taller. Keep the strokes evenly spaced. Remember to always hide the tip when beginning and ending Zhuan strokes to make nice, rounded ends (unlike the sharp ends of the Han goose tail).

2 The right-hand side is built downward. It is also larger than the left so ensure that it is balanced against the smaller part.

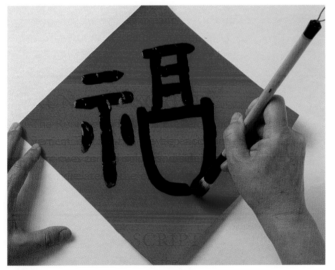

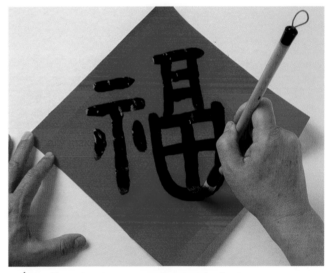

3 Remember to make the big enclosure at the base from two curved strokes which join at the bottom in the middle.

4 Finally make the two strokes inside the box.

RUNNING SCRIPT

The Running script joins the left-hand horizontal lift and vertical. The left-hand sweep also misses out the dot and continues to the right-hand side so that the two sides are closely related—the continuation of the *chi*.

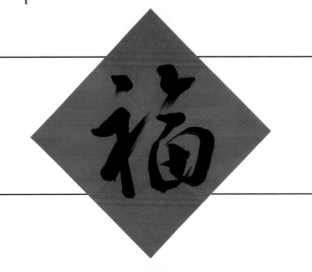

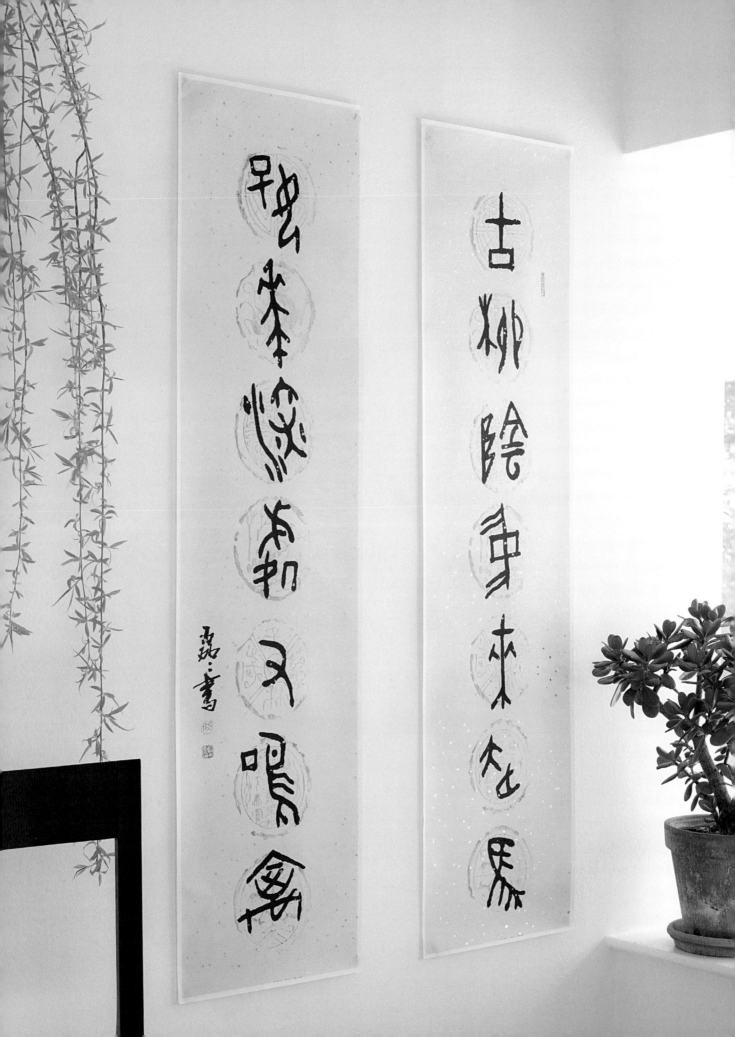

Contemplation Artwork

Calligraphy created to be framed as an artwork can be written in any format, size, or script. You could write a favorite poem, saying, or piece of philosophy, or write your own text. This project shows two sentences from a long poem called "Farewell, Sao" in which Qu Yuan, perhaps the most important poet from Chinese history, remembers a favorite place. It reads: "There is a long, long way ahead. I am going up and down to explore."

M A T E R I A L S

- Large sheet of calligraphy paper
- Small, mixed-hair brush
- Black ink

1 Fold the paper to make rectangular guides for each Zhuan script character, leaving a margin on all sides, and a larger margin at the top.

2 When folded vertically ensure that you are left with comfortable rectangle shapes. When the finished work is mounted all the creases will disappear.

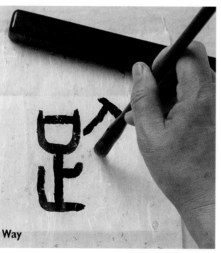

Way

3 *Lu:* The two halves of this character occupy equal space. The left-hand side is the foot radical—meaning "road." The strokes on both sides should be very well balanced.

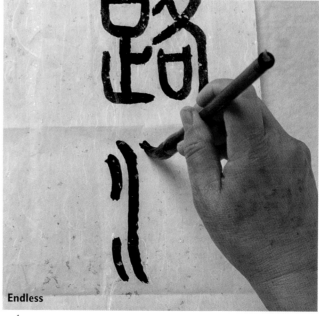

Endless

4 *Man:* This character includes the water radical. The short curves should follow the shape of the long curve.

TIP

- The Zhuan script of the Bronze Age features taller, more rectangular shapes so calculate the number of characters you are going to draw and fold the paper into the correct number of squares. Remember when you calculate to leave space on the left for the date, signature, and seal, and also leave a border all around.

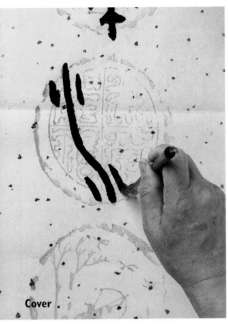

Cover

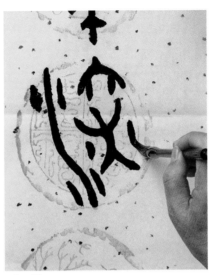

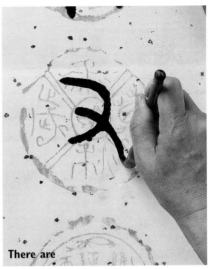

There are

9 *Shen*: The water radical on the left indicates that the character is closely related to water. The long curved stroke is followed by short strokes on either side to show the flowing of the water.

10 Make up the curves at the top and bottom from combined return strokes.

11 *Chu* and *You*: *You* is a very common mark in many pictographic characters because it is the sign for the hand, when you hold onto something you have it. The main curve is easy to make in one movement. Just remember to rotate your brush clockwise to keep the tip in the center of the stroke.

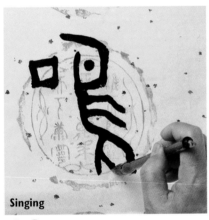

Singing

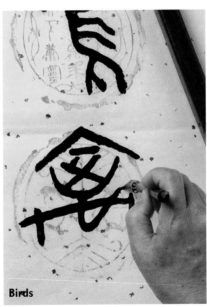

Birds

12 *Ming*: The character for bird-song is made up of two parts: the small radical on the left relates to the mouth, on the right is a bird. After the mouth the bird is made up from one bend stroke for the head and beak, a vertical to make up the neck and chest joined by a short horizontal beneath the eye, placed as a dot, two curved strokes for the wings and finally two strokes for the claw.

13 *Qin*: The last character indicates all types of birds. Two strokes build up the top triangle followed by the central strokes. Two strokes join in the center to make a long curve. The last stroke can be made in one movement, but remember to rotate the brush counterclockwise before bringing the brush back up.

14 On the left-hand side of the second sentence find a space to place your signature, in this case next to the most basic character. Finally, put your seal below the signature.

TIPS:
- You can use any type of paper but ready-made couplet paper is printed with decorative patterns which can act as a guide for the character position. It is usually in either five or seven character lengths so cut off any that are unnecessary. If you use normal plain paper you should fold it into the right number of squares so that your couplet balances.
- With the Pictographic script hold the brush like a knife or chisel as though cutting into the paper. When the brush is moving, do not use smooth strokes, instead make a series of dots joined together, like a chisel moving by being hammered in a series of movements.

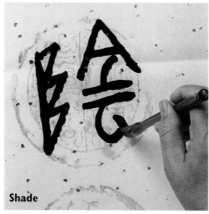

Shade

3 *Yin:* Again work from left to right and top to bottom. The final curve is made up of two strokes that meet at the bottom.

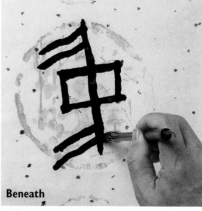

Beneath

4 *Zhong:* Write it slightly off-center as the left-hand side is slightly heavier. It is also helpful sometimes just to break the balance. *Lai* and *zou* follow.

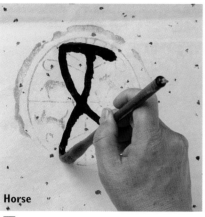

Horse

5 *Ma:* The horse starts with the top line of the head. The second stroke, which starts from the same point, shows the neck and back line through to the back leg. The third stroke is the back of the neck and front leg.

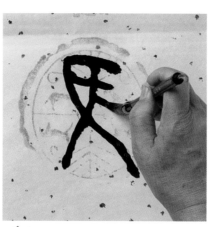

6 A horizontal stroke through the neck showing the face and mane is followed by one more small stroke to continue the mane.

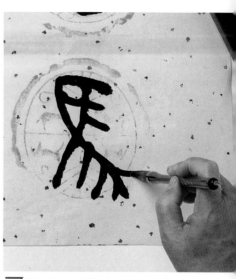

7 Continue with three more legs beneath and finally add a little tail on the bottom.

Flower

8 *Hao* and *Hua:* The character for "good" combines the radicals for "woman" and "son". On the right-hand side is a kneeling figure with crossed arms—"woman." On the left-hand side with a big head and small body is "son." *Hua,* the flower, shows the stalk, leaves and roots of the plant. Start with the top of the flower and stalk as a bend stroke, followed by the pointed sections of the flower and then the pairs of leaves and roots.

Hanging Couplets

The couplet is one of the most popular forms of calligraphy because it can be written in any style or script—the only rule is that the two strips must balance. Like a two-sentence poem, it can encompass any subject. The strips hang side-by-side, or on each side of a door or significant painting. They show a philosophical idea that is also decorative.

Couplets are made up of a pair of sentences. The number of characters on each side can range from three or four up to hundreds. The rule is that each character must balance with its opposite—verb with verb, adjective with adjective, and noun with noun—such as "blue sky, white cloud." The sentences in this Pictographic script couplet describe a scholar enjoying the spring: "Riding a horse in the shade of ancient willow wood; listening to the birds singing under the cover of the flowers." Refer to the photograph, opposite, for all the characters to include in this hanging couplet.

MATERIALS

- 2 sheets of 7-character couplet paper
- Small, mixed-hair brush
- Black ink

The individual characters are translated:

Good	**Ancient**
Flower	**Willow**
Cover	**Shade**
Place	**Beneath**
There are	**Come**
Singing	**Walking**
Birds	**Horse**

Ancient

| *Gu*: Begin writing the right-hand half of the couplet first. Start the first character with the horizontal and vertical. The rectangle is made up of three strokes: the left-hand vertical, the hook across and down, and the bottom horizontal enclosing the box.

Willow

2 *Liu*: The left-hand side is the wood radical: all kinds of tree use this radical in their character. Draw the long, straight trunk first and two short strokes joining it as branches with two more below as roots. The right-hand side indicates the type of tree: here the forms resemble the branches of the weeping willow. To help balance the character first make the two long strokes, followed by the curves on either side.

路漫漫其修遠兮吾將上下而求索

書于新年

5 If a character is repeated immediately, represent the second with a pair of dots, rather than the whole character. These two dots can be stretched into longer, horizontal strokes. Match the distance between the two strokes with the spacing of the previous character. The lines should sit at the top of the character space, leaving a large blank area beneath to make a more interesting composition.

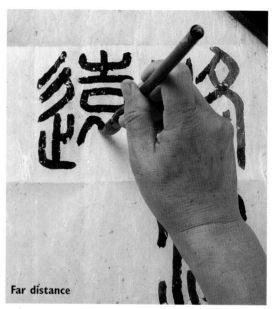

Far distance

6 *Yuan* has more strokes than usual. The left-hand side is the radical for walking but this occupies only a third of the space. Before you start the work, decide the distance between the strokes and keep them even, while also ensuring the character remains the correct size.

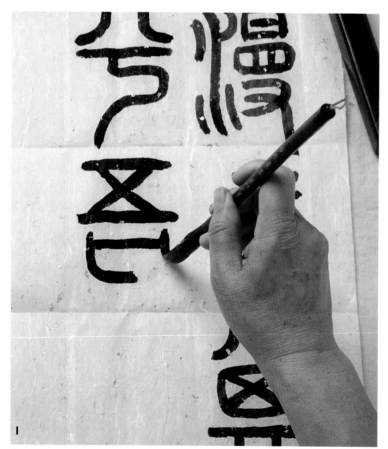

I

7 *Wu* is made up of upper and lower parts. It should also be symmetrical left and right so it is important for it to be properly balanced. Even though the top part has more strokes than the bottom, the underneath part can fill more space so that it looks comfortable on the paper. Keep your eyes in the center of the character to keep it symmetrical.

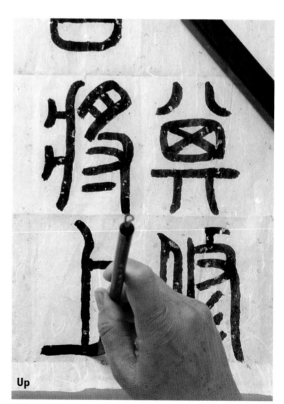

Up

8 *Shang* has only three strokes, so add definition to keep them interesting. Avoid straight, long lines.

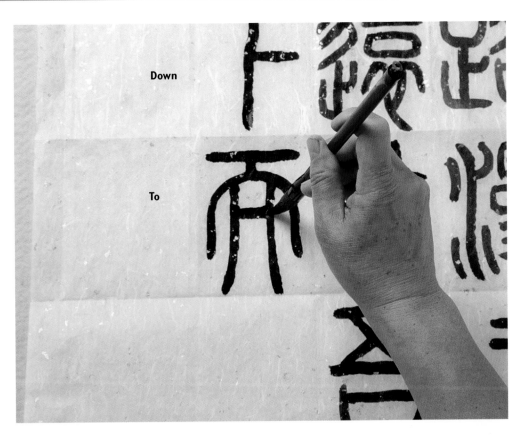

Down

To

9 In the Zhuan script, balanced and symmetrical characters like *er* concentrate their weight high to push the feeling of space up and give the character longer legs, a typical Bronze Age feature.

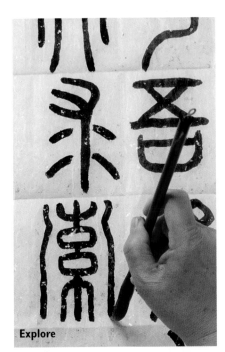

Explore

10 The character *suo* is also very symmetrical: write the center part first. At every point find the center before adding the sides, then ensure that the long strokes on either side match each other.

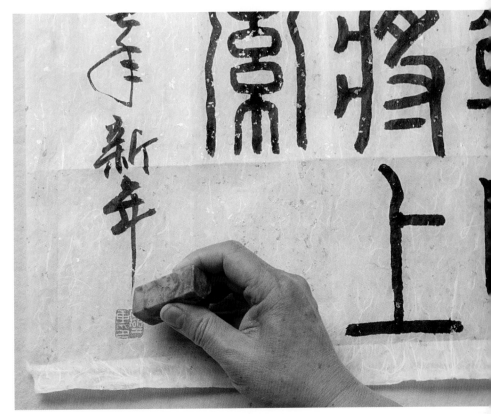

11 In the left-hand space place your signature and the date. Use Running script or Standard script, don't repeat the same script as the content.

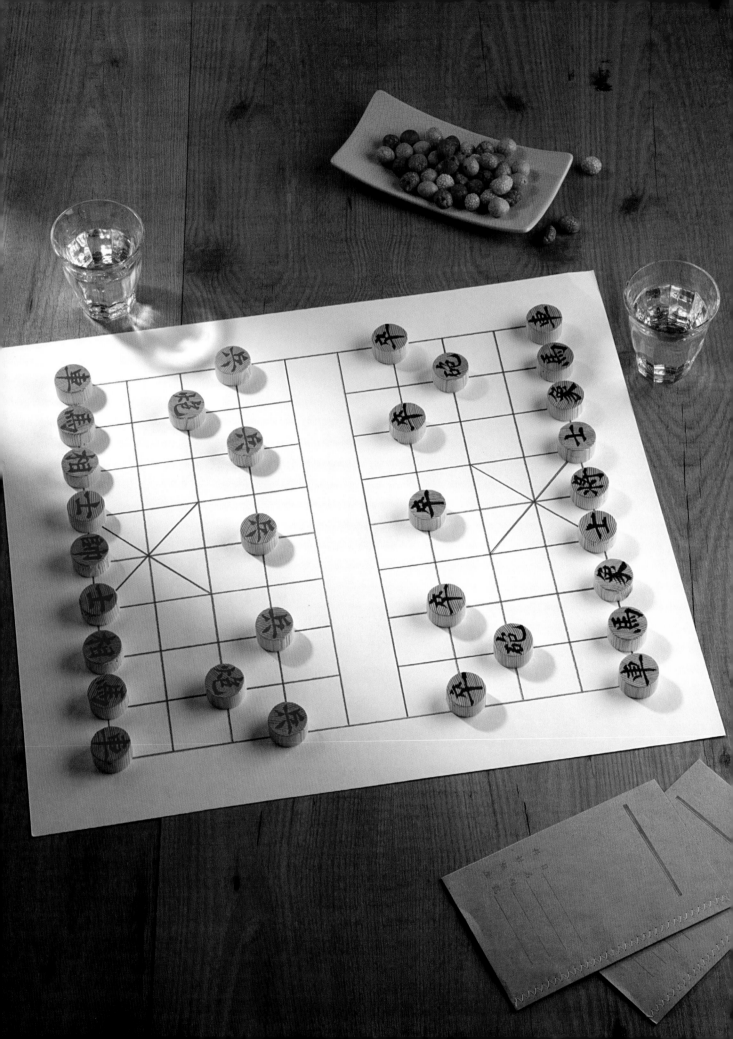

Chinese Chess Set

Originally called the "Elephant Game," Chinese chess developed in the Warrior States period (475–221 BCE). Representing two armies in battle, by the Tang Dynasty (7th century CE) the game had matured into that which is played today. Nowadays, it is more common than international chess —with which the Chinese version shares many similarities.

MATERIALS

- Wood, 2.5–5cm (1–2in.) diameter
- Pencil
- Ruler
- Saw
- Sandpaper
- Brush
- Black ink
- Red paint
- Varnish
- Large square white card
- Blue pencil/crayon

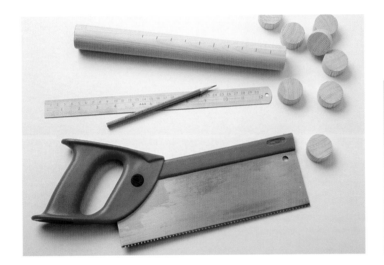

1 To make the 32 counters, measure the length of wood and mark every ⅝in. Then use the saw to cut the wood into the pieces.

TIPS

- Write the characters in Standard script and if you are worried that you might not remember which piece is which also write its name in English beside the character.
- Although the red and black sets use different names for some pieces—or use different characters—they have the same properties.

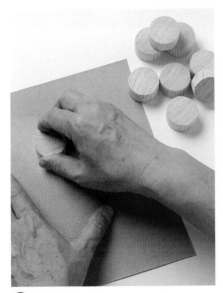

2 Rub each counter on a clean piece of sandpaper to smooth both sides flat as well, as round off any sharp edges.

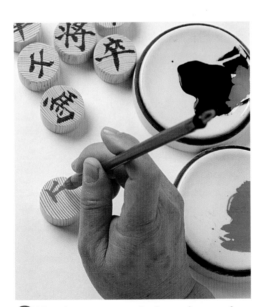

3 Use the image overleaf as reference for writing the names on the counters. Here one of the five soldiers is being painted. Paint the character from the top down.

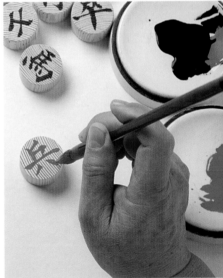

4 The last two strokes of the soldier should be shorter but space them wide apart in the middle of the bottom half of the counter to balance the character.

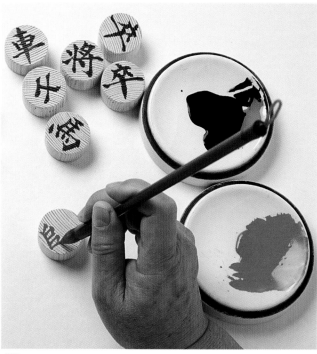

5 The character for the red Marshal is made up of a left-right type. Do the left first and build it up from the top toward the bottom.

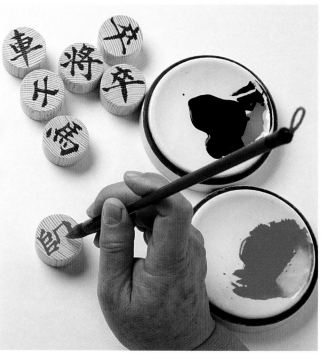

6 On the right-hand side draw the top and right side of the frame first and complete with a big vertical stroke.

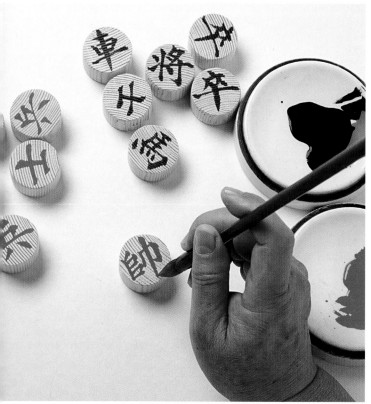

7 Complete the character with a big vertical stroke through the middle of the frame.

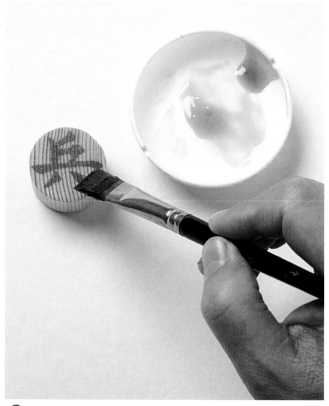

8 Once the paint is dry use a wide brush to cover the character with a layer of water-based varnish.

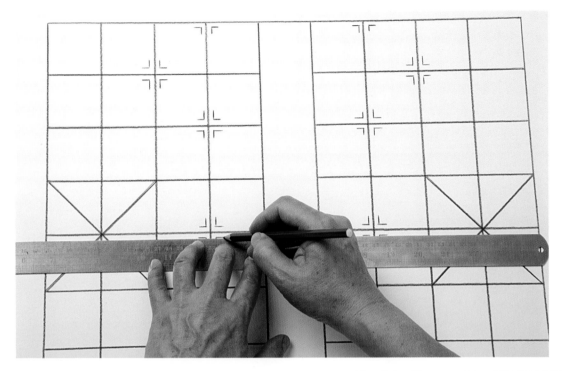

9 Choose the board size so that when two pieces are placed next to each other there is sufficient space for both of them. Draw out the grid leaving a blank space down the center, adding crossing lines in the center at the edges and emphasize the starting positions of the soldiers and cannons by adding check marks.

RULES

- The square board includes a river between the two armies and the pieces are placed on the crossing points, of which there are 90 on the board.
- Each piece moves in a particular way and the winner is the side which takes the other side's General, or Marshal.
- The red Marshal and black General must always stay inside the square palace, shown by the crossing lines, and can only move one step at a time.
- The guards can only move on the diagonal lines inside their respective palace.
- The red prime minister and black elephant move two squares diagonally corner-to-corner, unless another piece is blocking the move. They cannot cross the river.
- The horse moves like the knight in international chess—two squares forward and one across. He must always move two squares first so you cannot move if any other piece "stops the horse's leg" by blocking the first movement. The horse can cross the river.
- The cart is the equivalent of the castle in international chess, moving in a straight line as far as he can. He can also cross the river.
- The cannon also moves in a straight line but he can only take a piece if there is another piece sitting in between them.
- The red and black soldiers can only move forward one step at a time but once they have crossed the river they can also move horizontally. The soldiers take pieces directly in front of them, or next to them once they have crossed the river.

- To win, the opposition Marshal or General must be put in check before being taken.
- If it becomes impossible to put the opposition Marshal or General in check the game can end in a draw.

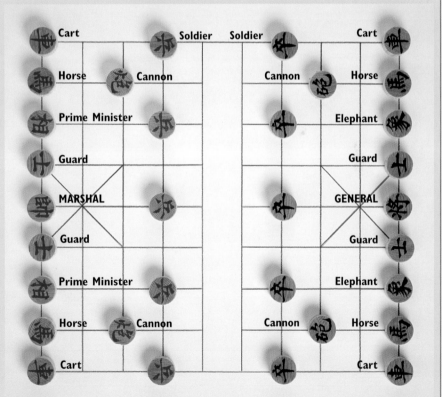

Pictographic Curtain

Decorating your own curtain or table cloth with the Pictographic script, used by the earliest artists, is wonderfully simple. The style reflects ancient cave paintings, showing what they saw and understood of nature and the world around them. It's also a good way to learn Chinese characters and link the ancient pictograms with modern characters.

MATERIALS

- Fabric
- Fabric paint—mixture of burnt sienna with a touch of red
- Medium-sized brush
- Iron

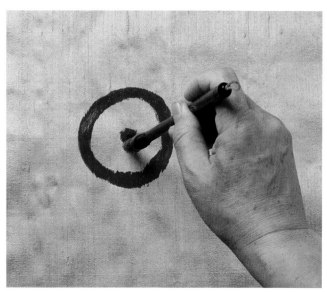

1 The first character represents the sun. Create the circle by joining two semi-circular strokes and place a dot in the center. Work slowly to ensure the paint is evenly distributed on the fabric.

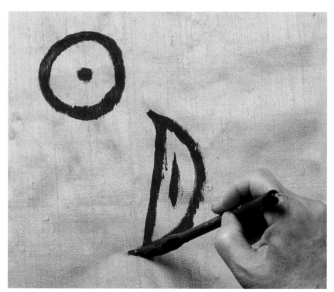

2 The second character is the moon but placed together with the sun, they give the meaning "bright."

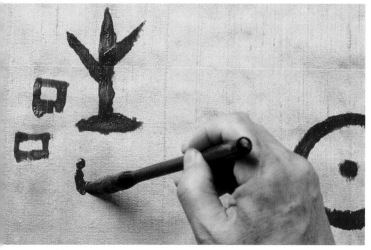

3 The vertical radical represents "rising" and the little squares surrounding it indicate stars.

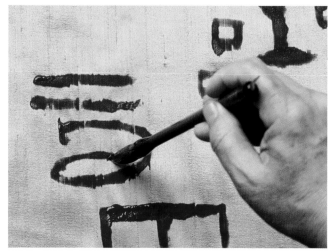

4 To show clouds create a long curved stroke from three individual strokes placed beneath two horizontal lines. Underneath the cloud is the rain.

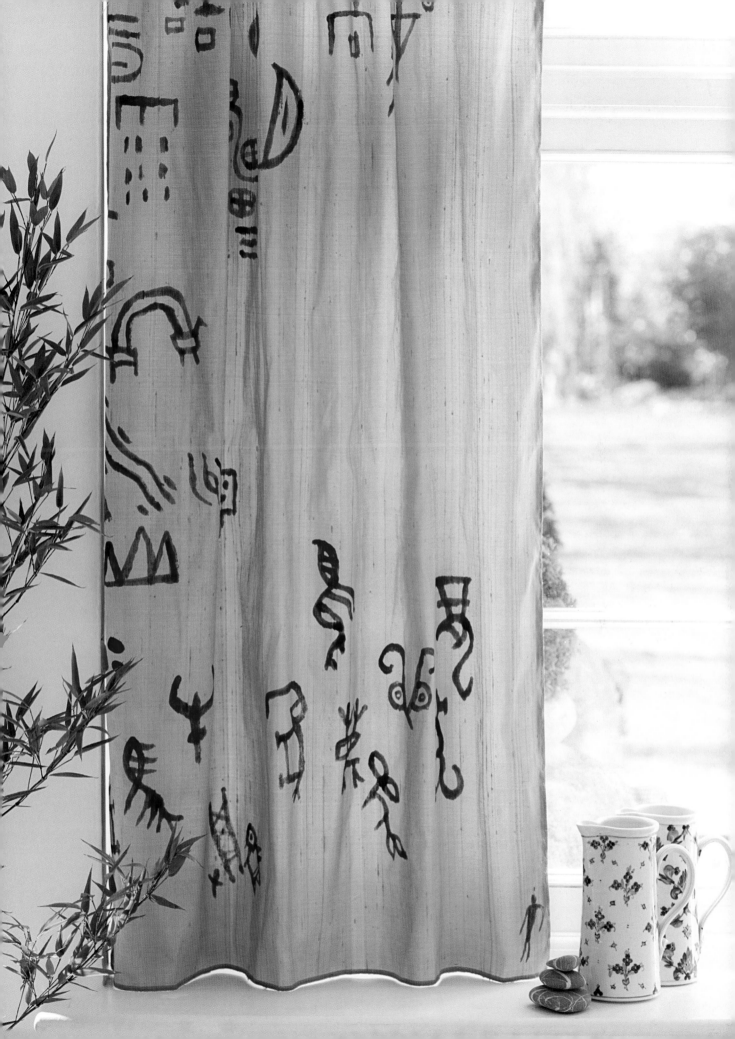

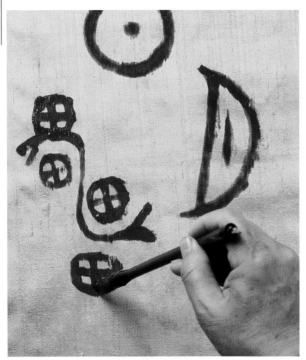

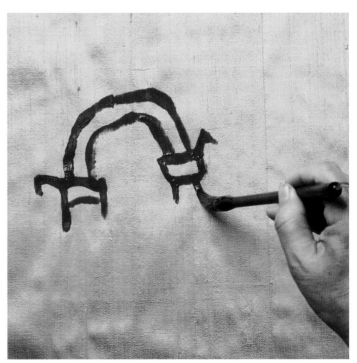

5 This character means thunder—shown by a curved line for lightning, surrounded by crossed circles representing the sound of thunder.

6 A rainbow was thought to be a heavenly bridge. Start by drawing the base on one side and then the long curves in a single brush stroke.

7 Add whatever characters relate to your main idea. Here the three lines show *chi*, meaning spirit or air.

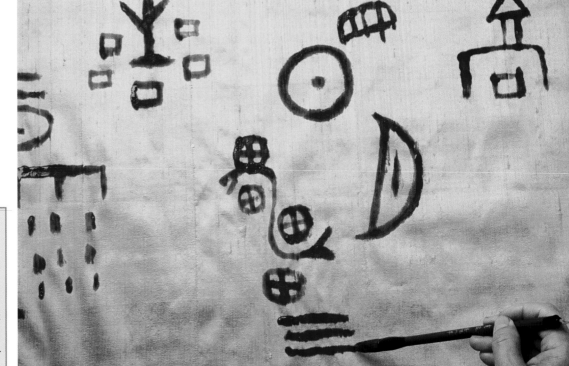

TIPS
- Try to mix a color that resembles the ancient pigments which were made out of animal blood.
- Fabric does not take paint as easily as paper so work slowly and press the brush tip firmly onto the surface.

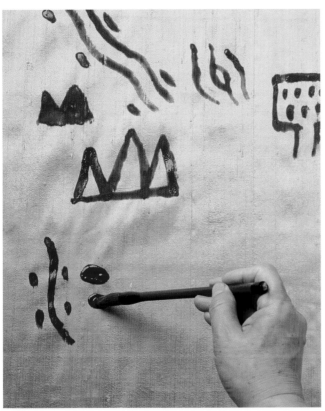

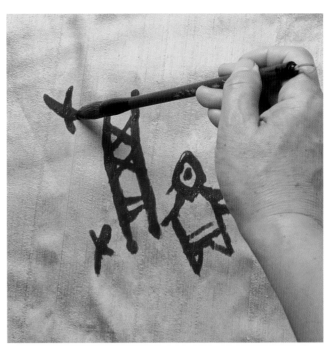

9 The top character shows an ox. The main character describes the concept of fishing by combining the characters of fish, net, and human hands.

8 The next group shows objects found on land: a river, made up of an enlarged water character; an island; a hill, mountain, and ice—shown by adding two dots to the water character.

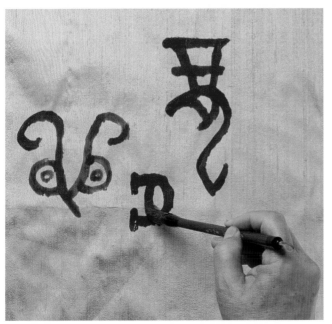

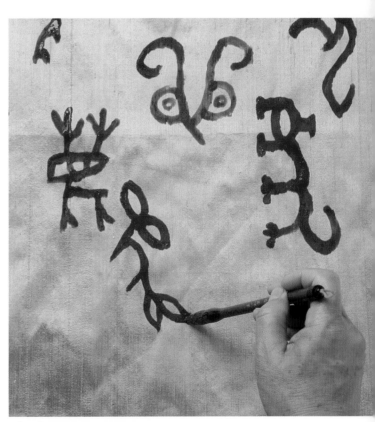

10 This group of animals includes an elephant, bird, deer, dragon, and the tiger's head. The central character—seeing—shows that they are all being watched.

11 The completed tiger is most usually written vertically. The final character is a fox.

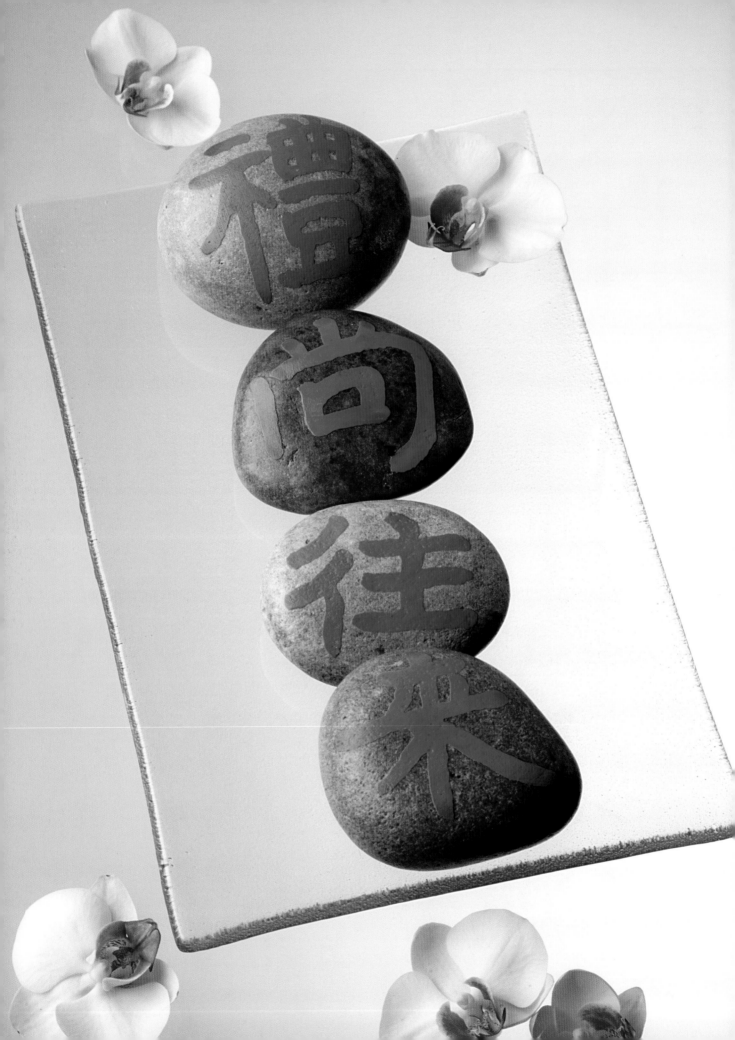

Philosophy Stones

Stone really shows the beauty of the natural world. The smooth pebble can be a very good material for writing calligraphy: write your favorite philosophical phrase and through this golden touch the stones can come alive and start talking. Remember that the Chinese language normally uses fewer words to express the same idea. The characters in the Standard Script project, for example, translate word for word as "Morality should go come."

MATERIALS

- Pebbles
- Medium to large brush
- Red and blue gouache paint
- Calligraphy gold paint
- Varnish

STANDARD SCRIPT The four characters translate as:

Morality decrees you should treat others the way you want to be treated.

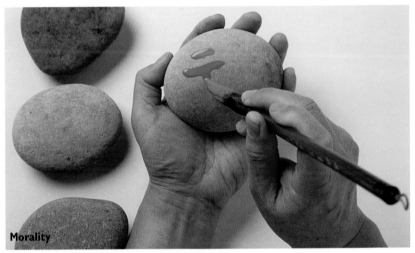

Morality

1 Holding the pebble stable in one hand, write *li*, a left-right type character. Build up the left-hand side from the top dot down.

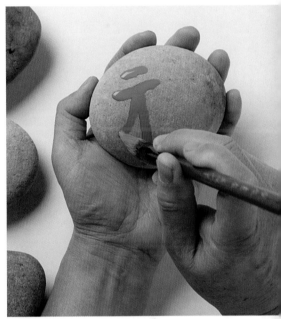

2 Draw a vertical line with a diagonal on each side.

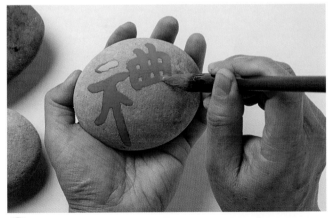

3 The right-hand side includes the character for music at the top. Draw three sides of the frame first before adding the lines inside and finally closing the frame.

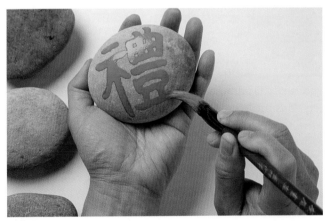

4 Continue drawing the strokes underneath, finishing the last stroke in line with the bottom of the left-hand side.

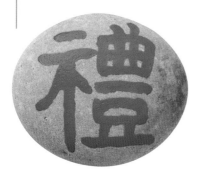

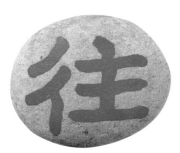

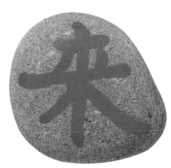

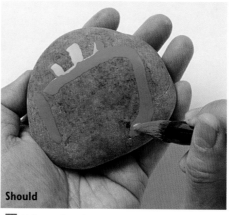

Should

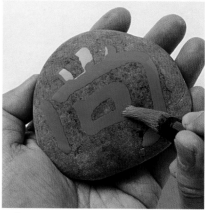

5 Write the three dots of *shang* at the top, then the left-hand vertical, followed by a long curved stroke.

6 Inside the frame, again draw the left-hand vertical first followed by a curved stroke. The final stroke to close the box is from left to right.

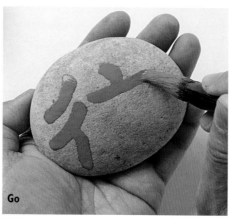

Go

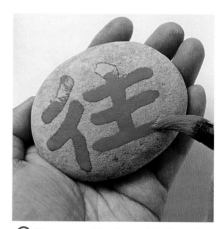

7 *Wang* begins with the three strokes of the left-hand side followed by the dot and horizontal on the right.

8 The second horizontal, followed by the vertical, make up the cross. Finish with a final horizontal.

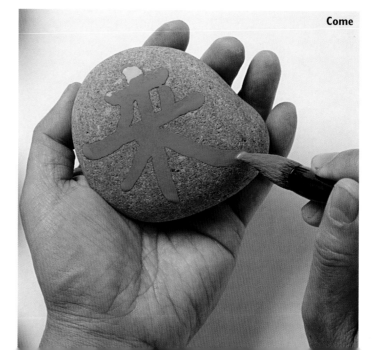

Come

9 Choose a larger stone for the final character, *lai*, which requires extra space in the bottom right for the long slice stroke.

TIPS
- Because each stone's surface is not flat the hand holding the stone must also move when you are writing to ensure the surface remains flat.
- Lay out the stones in any way you like, horizontally or vertically, placed in the house or outside in the garden.
- If placed outdoors remember to varnish the stones once the paint is dry.

HAN OFFICIAL SCRIPT The four characters translate as:
Kindliness is to (literal translation 'which') love people

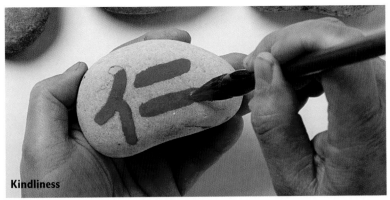

Kindliness

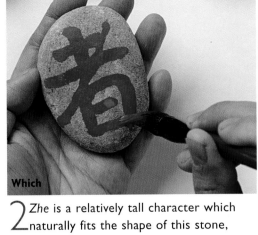

Which

1 To write *ren,* follow the two short strokes on the left with two long horizontals. Remember always to hide the tip at the end of the stroke to give the line a round end.

2 *Zhe* is a relatively tall character which naturally fits the shape of this stone, making the message more interesting.

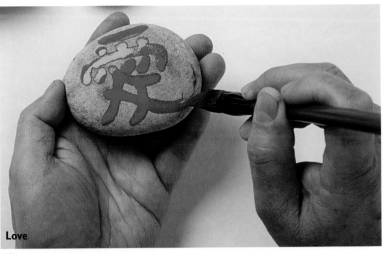

Love

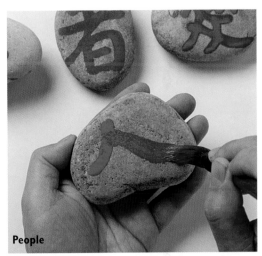

People

3 *Ai* must be built stroke-by-stroke from the top downward, ending with a long goose tail stroke. This character could be drawn by itself and presented to the one you love.

4 The final character is also pronounced *ren* but here means "people." As a relatively simple character, deliberately make each stroke heavier, especially emphasizing the last goose tail stroke.

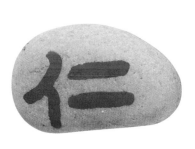

RUNNING SCRIPT The five characters translate as:

True gentlemen are those who, although different, can live together in harmony

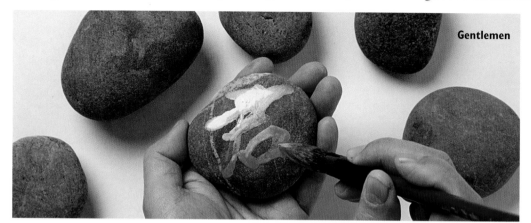

Gentlemen

1 The first character, *jun*, combines with the next character to mean "gentleman." Start with the top horizontal but link it with the following horizontal and long aside in a single movement. Finish with the bottom square.

2 *Zi*: write all three strokes—the top bend, the curved hook, and the final horizontal—in a continuous movement.

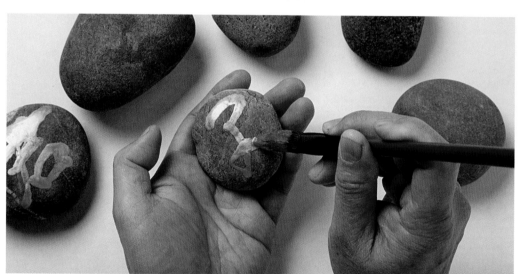

TIPS:

• If you cannot easily find pebbles close to home, or travel to a beach or the mountains yourself, you can buy bags of evenly sized stones at garden centers everywhere.

• If you make a mistake you can immediately wash off the paint and try again. If you are using oil-based ink it is easy to use white spirit, otherwise just rub water-based paint away before it dries.

• Use any size or shape of stone you like. If you want to emphasize any character you can paint it on a bigger stone.

• Use a mixed-hair of soft brush, a hard brush will not allow the stroke to be plump.
Always use a bigger brush to do small work—never use a small brush to try and do big calligraphy.

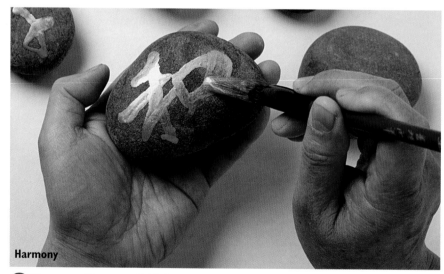

Harmony

3 *He* means "harmony." All five strokes on the left, from the aside, through the horizontal, vertical diagonal and final horizontal, are combined. The character is finished with the square on the right.

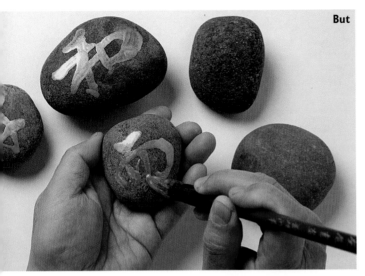

But

4 Start the character *er* with a little horizontal and combine it with a frame made from a long, sweeping curve. Link them up with two short verticals.

5 *Bu* is much simplified in Running script, leaving a large dot at the top, linked to a long hook with a dot on either side.

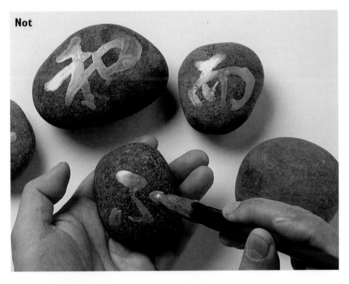

Not

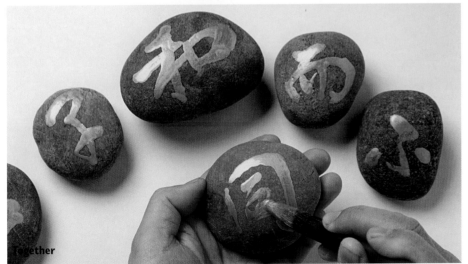

Together

6 The final character, *tong*, means "together". Make the left-hand vertical first and build the frame with a large hook stroke. Finish with the inside.

Decorative Lampshades

Decorating a lampshade with poetry is not only enjoyable but through its beauty it can remind us of the message every time we turn on the light—as Confucius said, "To review knowledge is as important as to learn it." Any calligraphy script can be used and the size of the writing and the length of the message are both completely open. For example, the piece written on the first shade is called the *Lan Ting Xu*, the most famous running script calligraphy piece in history by Wang Xi Zhi (4th century CE) in which he described a gathering of intellectuals. Throughout history every calligrapher has studied the piece—so this shade has been turned into something sophisticated as well as beautiful.

MATERIALS

- Small calligraphy brush, stiff hair
- Ink
- Lampshade

TIP
- The shape and color of the lampshade should be co-ordinated with the content and concept of the calligraphy.

ZHUAN SCRIPT

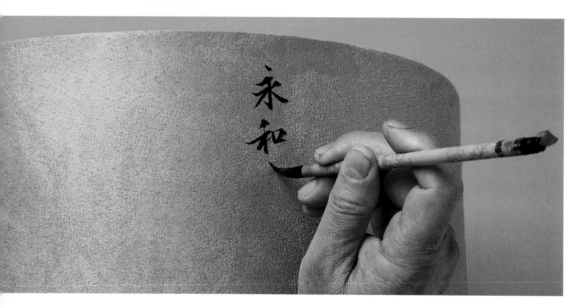

1 Rest the lampshade on the table and use one hand to hold it steady. Either stand or sit but ensure that your body position is comfortable. Place the original of the work to be copied where it is easy to read.

2 Before you begin, count the number of characters on the original and calculate the size the characters will need to be to fit the same line lengths on the shade.

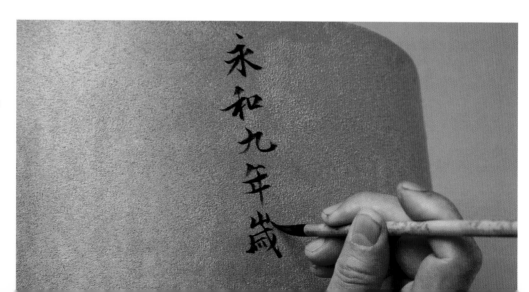

也 群賢畢至 少長咸集 此地
有崇山峻嶺 茂林修竹 又有清流激
湍 映帶左右 引以為流觴曲水
列坐其次 雖無絲竹管弦之
一觴一詠 亦足以暢敘幽情
是日也 天朗氣清 惠風和暢 仰
觀宇宙之大 俯察品類之盛
所以遊目騁懷
信可樂也 夫人之相與 俯仰
或取諸懷抱 悟言一室之內
或因寄所託 放浪形骸之外

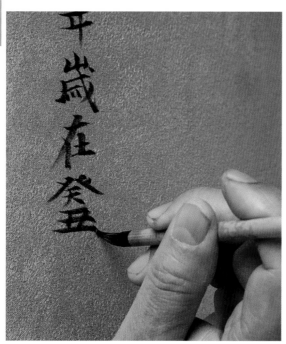

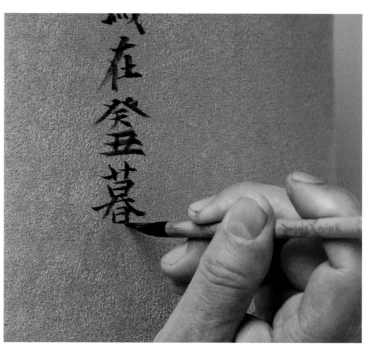

3 The two characters—*gui* and *chou*—indicate a year date so squeeze them both into the space of a single character.

4 When you copy a masterpiece try to look at each character as a whole and write it in one go to keep the movement, or *chi*, flowing. Don't break it up into individual strokes.

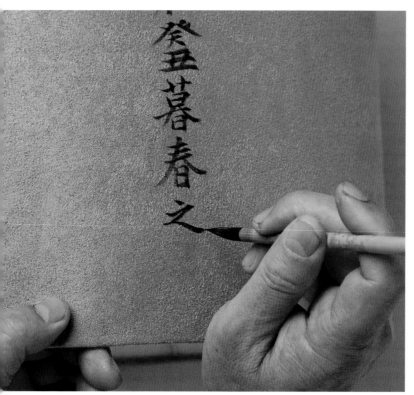

5 This character, *zh*, the equivalent of "of," is one of the most used words in classic Chinese. In this particular piece this character appears more than 20 times. Make sure each one is slightly different.

6 When writing towards the bottom of each column, hold the shade firmly as the right hand now has no resting place. Don't be afraid to keep your brush flowing.

7 Take care to start the second column a comfortable distance from the first column as the gap must be replicated for every other column as well.

8 Wherever the character is positioned, the relationship between the brush and surface should be like it was on the table—kept straight, with the brush vertical.

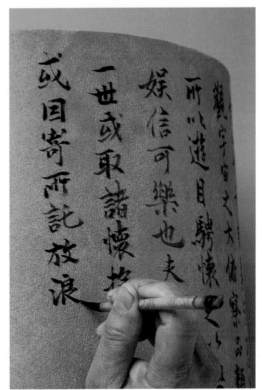

9 The character *da*, meaning "big," includes a slice stroke, though this should change to a long dot in Running script.

10 Rotate the brush in the fingers all the time, keeping the tip in the center of the stroke.

HAN OFFICIAL SCRIPT

Zhi yuan means "Reach further"—in both your career and knowledge. It comes from the saying "The stiller your mind can become, the further your thoughts can reach."

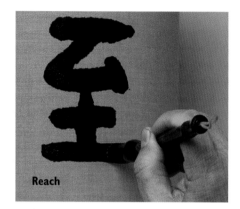

Reach

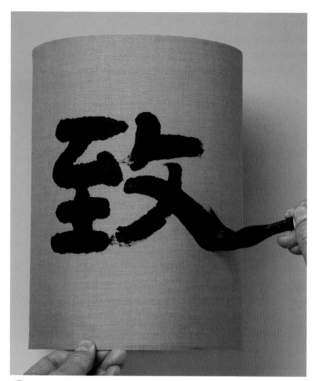

1 Because each character is very big there is only space to include two. Use a big brush to write *zhi* but remember to hide the tip at the beginning and end and make each stroke plump and full.

2 Follow the top and aside to left on the right-hand side by emphasizing the last stroke, the goose tail.

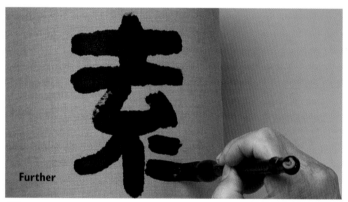

Further

3 Turn the shade almost all the way round and write *yuan*, a semi-enclosed type of character. Write the right-hand side of the character first, starting with the top part.

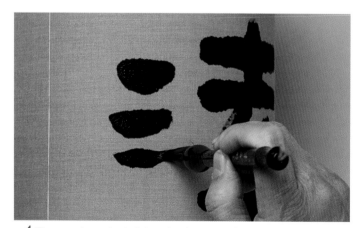

4 To complete the left-hand side, start slightly lower than the right and draw three horizontal dots.

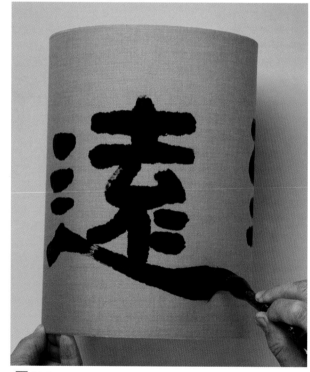

5 Make a small stroke to the left before immediately returning to the right-hand side of the character. Gradually press the brush down hard as you reach the end before lifting it away to make the goose tail.

HAN OFFICIAL AND ZHUAN

Ting yu translates as "listening to the rain."
Because it is a more relaxed message you can
use mineral green paint.

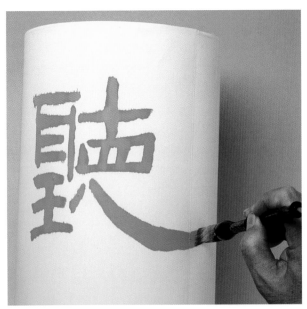

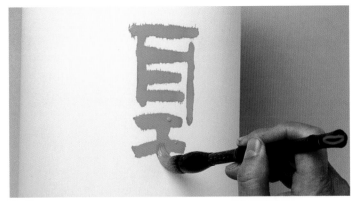

1 Start with the ear radical—part of the character for "listening"—at the top left. Keep all the horizontal strokes roughly the same distance apart, but arranged quite densely.

2 The right-hand side occupies more space so emphasize the long goose tail stroke.

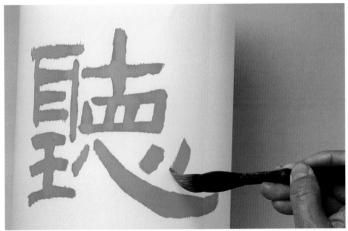

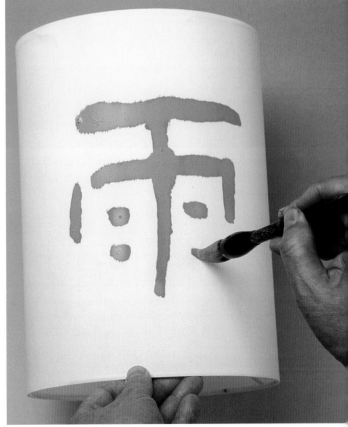

3 Complete the character with two dots.

4 The character for "rain" starts with a long horizontal which indicates the sky.

5 The vertical strokes and dots indicate the raindrops falling. The character is symmetrical but try to break it up while still retaining balance. Finally, print your seal beside the character.

Greetings Cards

The Chinese concept of "Double Happiness" is most often used on a gift or as a wedding celebration, written in red or gold—but never black—ink. This sign has been used continuously for many thousands of years and can be written in any script and on any material from lacquer to gold leaf. Here the character is introduced simply, as the main image on a greetings card.

MATERIALS

- Plain card
- Large mixed-hair "white cloud" brush
- Red paint
- Mineral green pigment
- Gold calligraphy paint

ZHUAN SCRIPT

1 Begin the "double happiness" symbol in Zhuan script using a large mixed-hair brush—the "white cloud" brush is best.

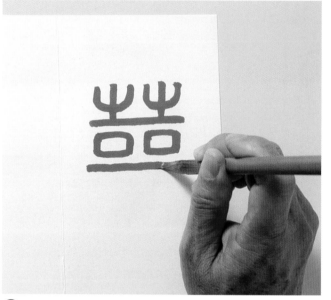

2 Make the beginning and end of the horizontal strokes even by hiding the tip and ensuring the distance between the strokes is a regular, comfortable distance.

TIPS
- Look at the composition—the size and position of the character on the card. From the very first stroke you must concentrate on placing the character in the right place.
- Use any color combination of paper and ink—just remember never to use black ink on white paper.

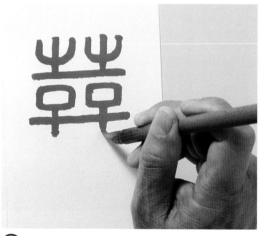

3 It is important to keep both sides of the symbol symmetrical—don't allow one side to become larger or longer than the other.

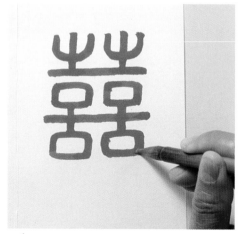

4 Finish by repeating the circular motifs, again ensuring that the whole character is in proportion.

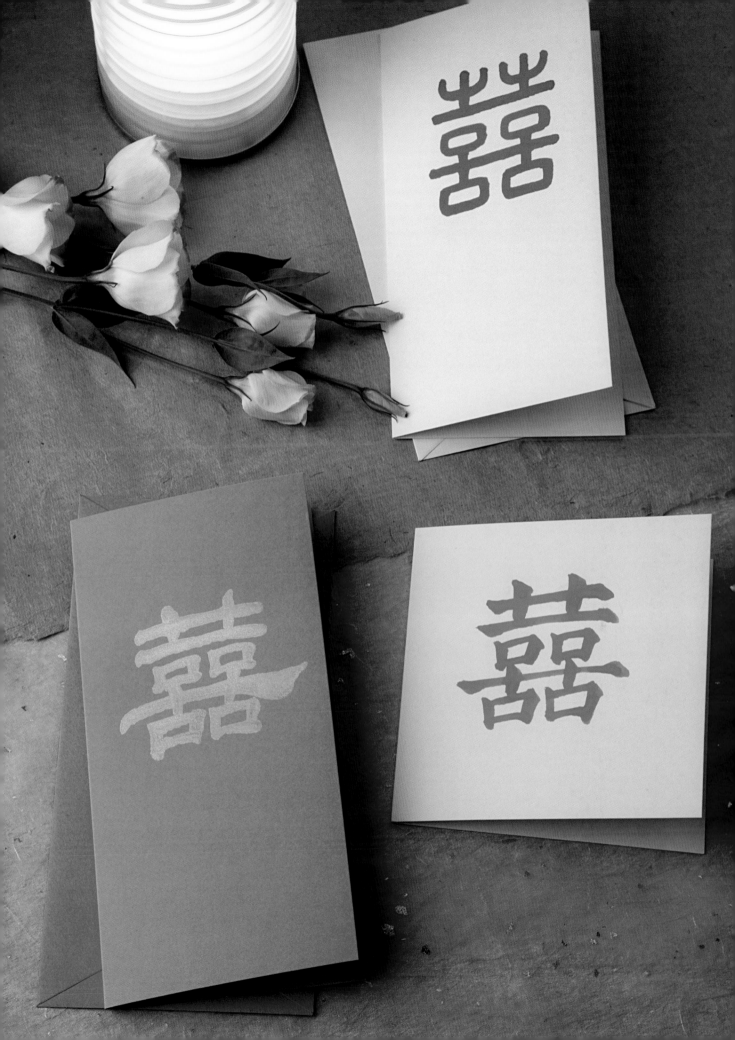

HAN SCRIPT

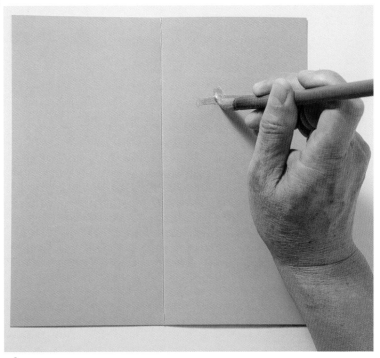

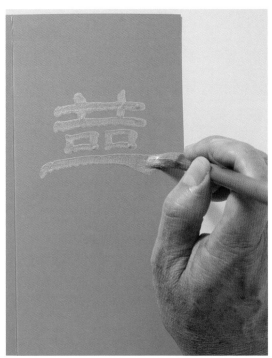

1 Use gold paint to emphasize the more curvaceous character shapes found in the Han script.

2 The goose tail stroke in the center means the character will not have perfect symmetry so consider the shapes of the rectangles above and below the line.

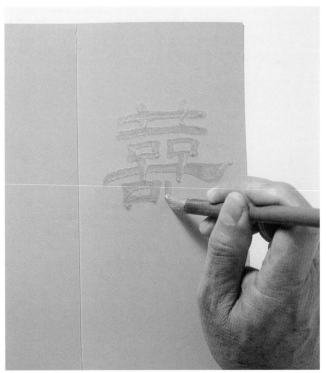

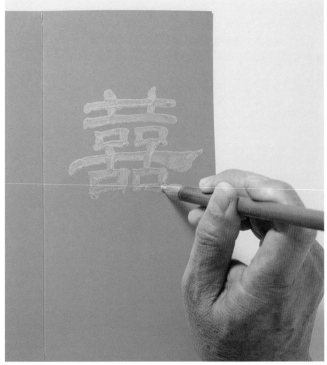

3 Because the lower two squares are used to stabilize the character, make them slightly bigger and stronger compared to the top two squares.

4 Move the brush slowly towards the final stroke—don't rush as you reach the end of the character.

STANDARD SCRIPT

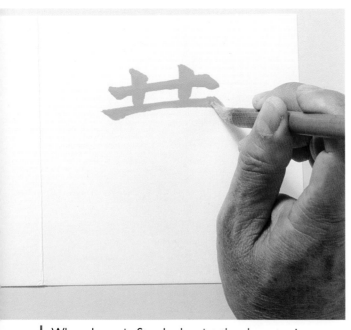

1 When drawn in Standard script the character is even more freely formed so take care to make it sit centrally on the front of your card.

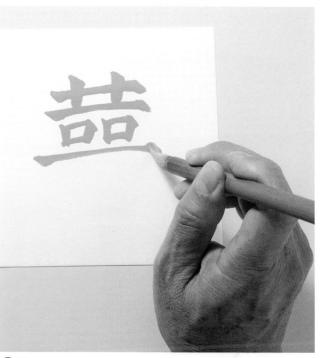

2 There are three long horizontal strokes so make their lengths and thicknesses all slightly different. The third line acts like a beam holding the character together but avoid making it too heavy by making the waist thinner.

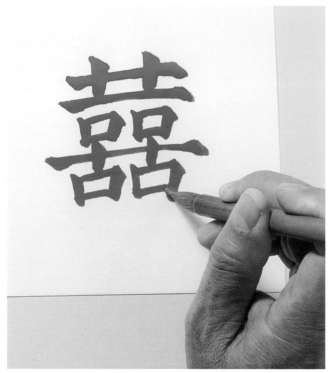

3 The two lower squares hold the whole structure together, so make sure they are strong enough to hold up the character—like the foundations of a building.

ALTERNATIVE COLORS
Write on any colored card, perhaps also consider using a red background.

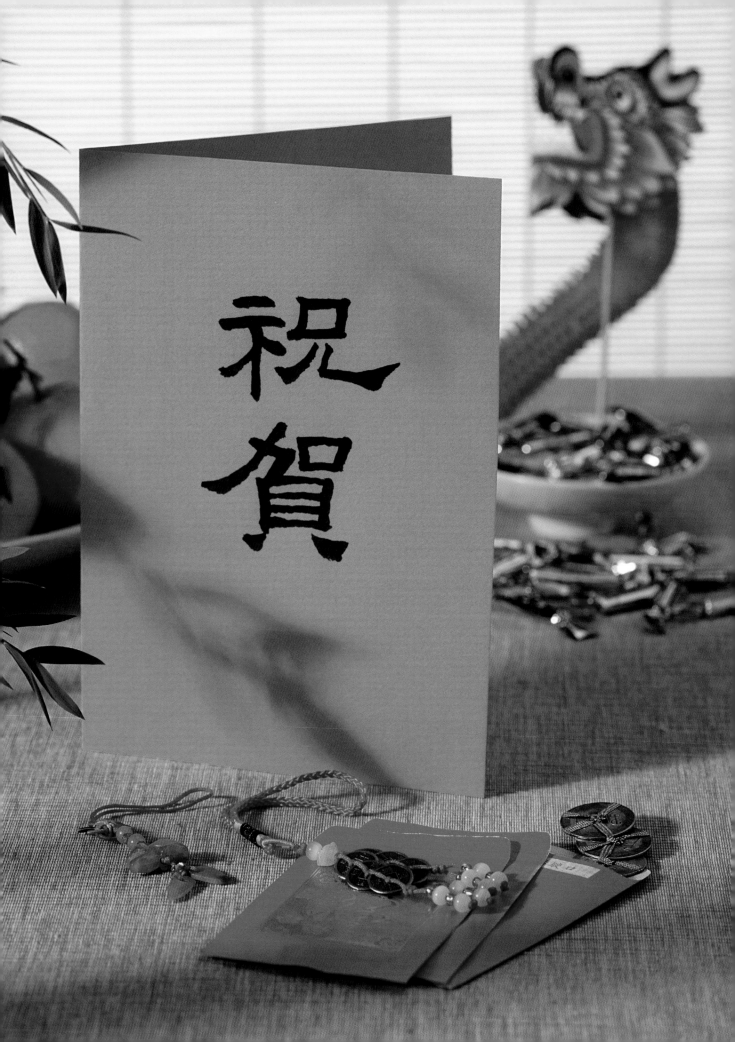

Congratulations Card

Many of the great masterpieces of Chinese calligraphy are just a brief letter, a short note, or a simple greeting—all are part of the calligrapher's life. Nowadays the greeting card is one of the most popular ways for people to communicate with one another, so creating your own card can make it more personal and sincere. It is suitable for any occasion with a message celebrating a birthday, recovery from illlness, or congratulations.

MATERIALS

- Colored card
- Mixed-hair brush
- Ink or colored paint

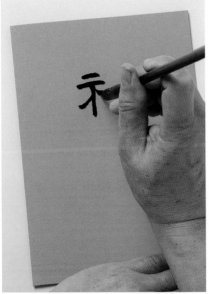

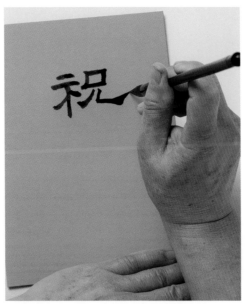

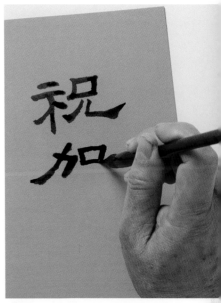

1 First fold your card. Two characters make up the word "congratulations," the first of which is *zhu* which on its own means "wish." In the Han Official script begin with the top horizontals followed by a vertical. The left aside and right dot follow.

2 On the right-hand side write the top square first then a left aside then a short vertical with a bend that turns into a goose tail.

3 *He*, meaning "congratulate," is made of two vertical parts, with the top also split into left and right sides. Begin at the top left.

4 The left-hand side vertical stroke is joined to the top horizontal which bends down to create three sides of a frame. Then inside add two strokes before closing the frame. Finally, add two dots at the bottom corners, the right-hand dot turning into a small goose tail.

TIP
- It is a good idea to use either colored card or paint, but avoid using black ink on white card: in China this combination is used only to mark a bereavement.

STANDARD SCRIPT
Happy birthday
Birthdays are big celebrations in China. Send a special card to mark the return of someone's Zodiac sign in every twelfth year. Babies also have extra celebrations after one month and 100 days.

Zodiac Greetings Cards

The Chinese use a lunar calendar and each year is represented by a different animal to match the twelve earth numbers. From Chinese New Year, usually in early February, newborn babies will have a specific sign. A Zodiac card can be used to celebrate either the new year or someone's birthday—if you know in which year they were born!

MATERIALS

- Chinese paper
- Backing card
- Small brush
- Ink
- Seal
- Red paint
- Water-based glue

DRAGON

1 Made up of a left-right character, start writing the Standard script character at the top left, making each stroke individually.

2 The right-hand side also starts at the top. After the top horizontal and vertical, make a bend stroke. Give the turn—the shoulder—weight by slightly lifting the brush before pressing down again as you move the brush into the vertical.

3 The big tail of the dragon should end in a long curved hook. When you reach the final hook, rotate the brush counterclockwise as you lift it up, controlling the tip to leave a sharp point.

4 Add the spines of the dragon's back as short, sharp, horizontal brush strokes, arranged evenly inside the long hook.

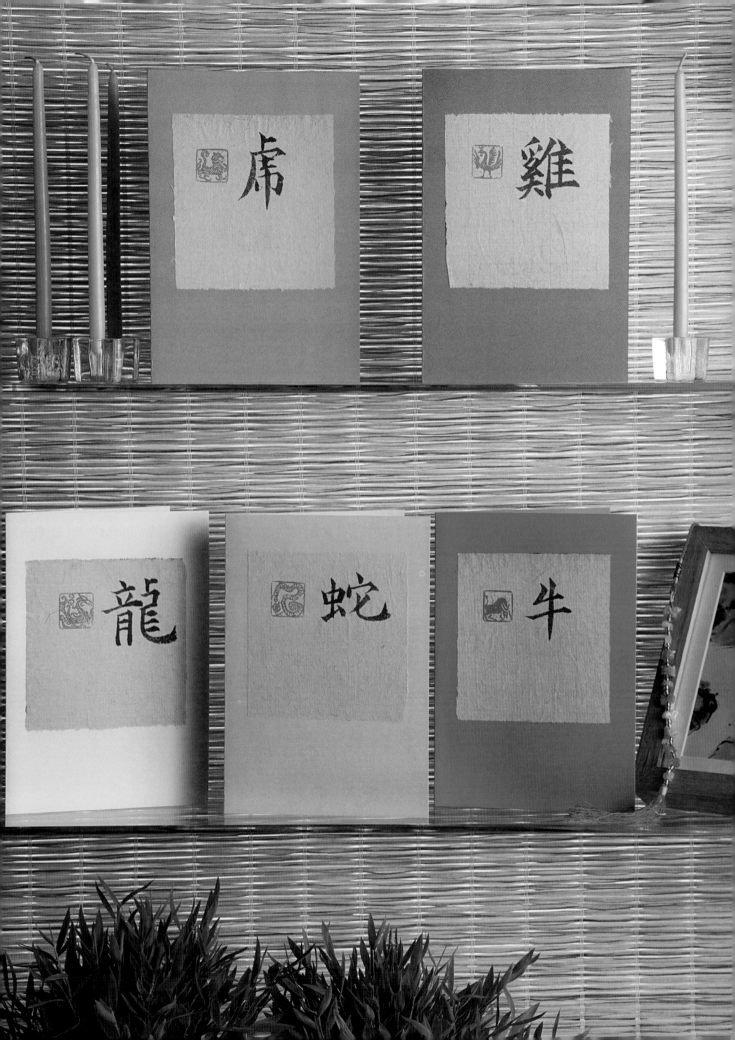

RABBIT

1 You can still see the original pictographic features of the two long ears and long legs. After building up the top and middle sections make a left sweep, turning the tip clockwise while moving the brush.

2 Make a long, curved hook to show the second leg, rotating the brush counterclockwise as you finish.

3 Do not turn the brush back before completing the final dot: start the dot and rotate the brush back as you make the mark. Make the brush movement as though you are following the "yin-yang" pattern.

TIPS

• If you do not have a seal with an image of a particular animal, decorate the paper with a small but simple line drawing or write the year instead.

• When making up more than one card at the same time, tear up squares of paper from the same sheet before you begin to write the calligraphy.

MONKEY

1 Although the character is built up from three horizontal parts it should be square so take care to arrange the space properly. Start from the left with the radical that shows it is an animal. Make the horizontal, followed by the vertical and the hook.

2 The middle section should be quite thin and positioned close to the animal radical so that they both occupy around half the space.

3 The right-hand side starts with a top bend followed by horizontal strokes, forming the character by moving downward.

4 The final two dots are a pair so ensure they are clearly related, while also ensuring that the bottom right dot is in the corner, stabilizing the whole character.

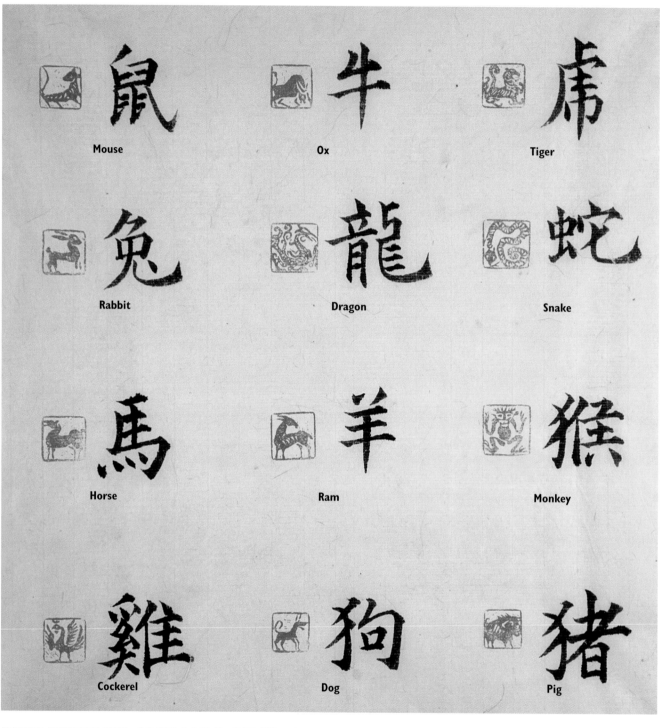

Mouse

Ox

Tiger

Rabbit

Dragon

Snake

Horse

Ram

Monkey

Cockerel

Dog

Pig

THE TWELVE ANIMALS OF THE CHINESE ZODIAC

Each sign of the Chinese Zodiac returns every 12 years. Use this chart to find the appropriate sign:

1 Mouse	1936, 1948, 1960, 1972, 1984, 1996, 2008	7 Horse	1942, 1954, 1966, 1978, 1990, 2002, 2014
2 Ox	1937, 1949, 1961, 1973, 1985, 1997, 2009	8 Ram	1943, 1955, 1967, 1979, 1991, 2003, 2015
3 Tiger	1938, 1950, 1962, 1974, 1986, 1998, 2010	9 Monkey	1944, 1956, 1968, 1980, 1992, 2004, 2016
4 Rabbit	1939, 1951, 1963, 1975, 1987, 1999, 2011	10 Cockerel	1945, 1957, 1969, 1981, 1993, 2005, 2017
5 Dragon	1940, 1952, 1964, 1976, 1988, 2000, 2012	11 Dog	1946, 1959, 1971, 1983, 1994, 2006, 2018
6 Snake	1941, 1953, 1965, 1977, 1989, 2001, 2013	12 Pig	1947, 1960, 1972, 1984, 1995, 2007, 2019

FINISHING OFF

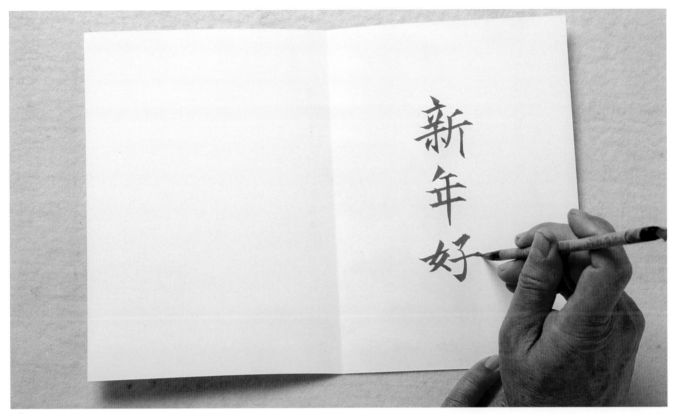

| This new year's card uses red paint on a white card. The characters *xin*, *nian*, and *hao* mean "Have a Good New Year."

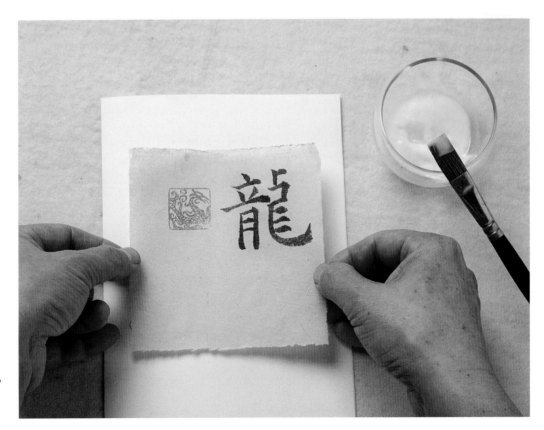

2 Finally, stick the zodiac calligraphy to the front of the card using water-based glue.

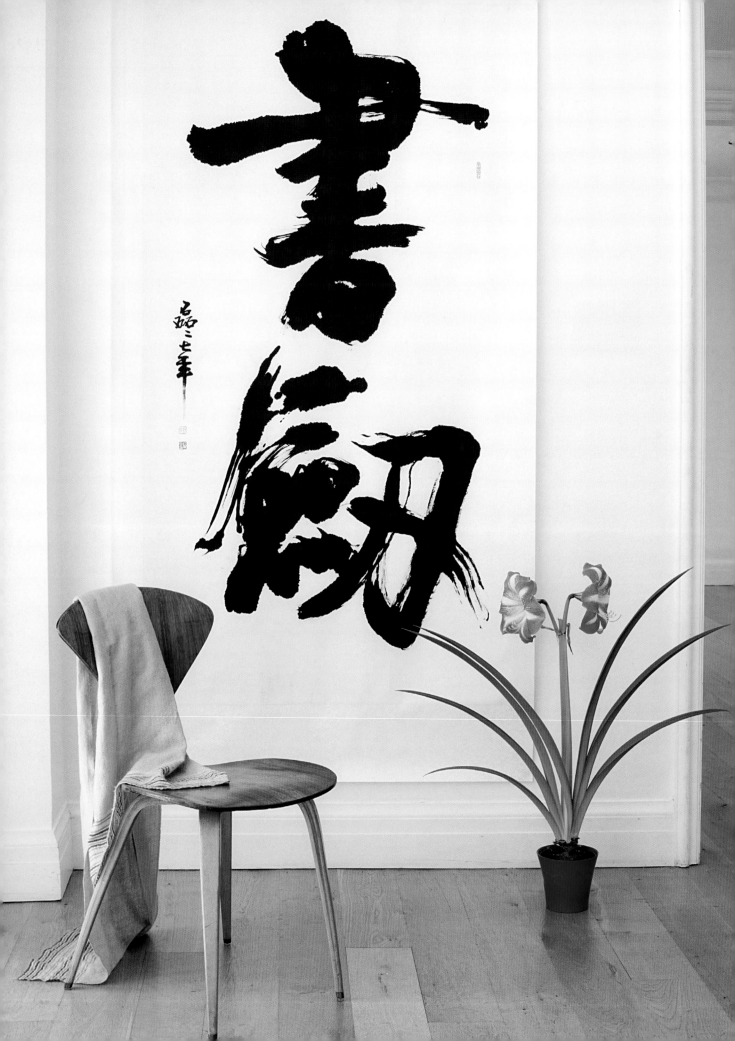

Bang Shu

Literally meaning "very large calligraphy," *bang shu* mark important messages in an important location. Because of the scale and the materials involved some practice is necessary, including working out the steps you must make around the calligraphy. Once the brush has touched the paper you won't have any time to think about where to go next, so everything must be ready before you start. Don't forget to prepare enough ink in a large container, and protect your studio with old blankets and your clothes with overalls. A *bang shu* is normally made up of only one or two characters: here *zhu*—meaning book, calligraphy or knowledge— and *jian*—meaning sword, warrior or bravery. In ancient China, people tended to place these two concepts together to try and catch both qualities in one: a scholar should use his brush in the same way that he would use his sword, with no compromise. A warrior should use his sword like a brush, with intelligence.

MATERIALS

- Extra large calligraphy paper
- Giant brush
- Small, mixed-hair brush
- Black ink
- Large ink container
- Seal and seal ink

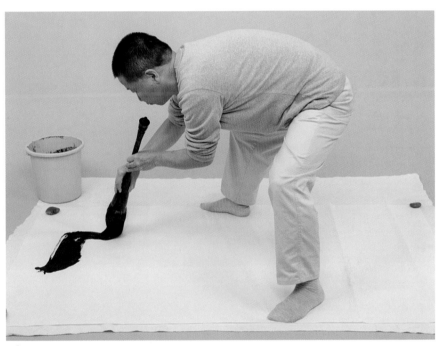

1 The first stroke is a horizontal with a bend down to the right. Press down hard but as the brush will be very full of ink move quickly so that it doesn't spread out of control.

TIPS

- Before you start, look at the paper and imagine how the calligraphy should look. Later, with the tracks already in your mind, the brush should follow your imagination.
- Stand in the correct position, centering yourself as you prepare to write.
- After your brush touches the paper you must write without stopping, the characters must be drawn in one go without refilling the brush with ink.
- The right hand should hold the lower part of the brush moving it from left to right, as well as up and down. The left hand holds the upper part of the brush relatively loosely. It should follow the right hand's movement to give it support.

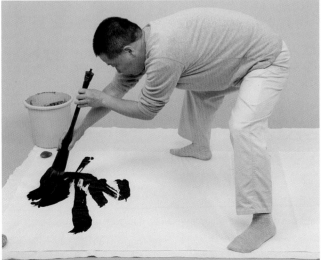

2 Add three short, horizontal strokes then take the brush up to the top center and prepare to make a long vertical stroke.

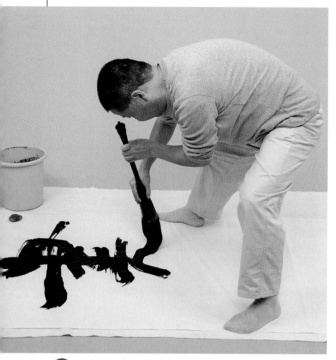

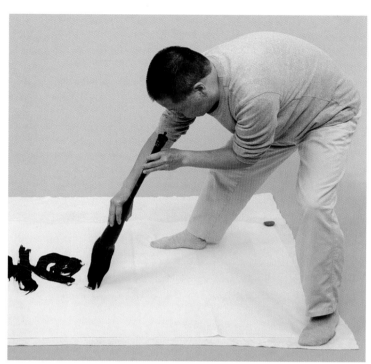

3 Hold the brush and pull it straight down with a slight kink to the left, before turning it back on itself and working toward your right foot.

4 Fill the space made with two short horizontals then move your left leg one step back, ready to start the second character.

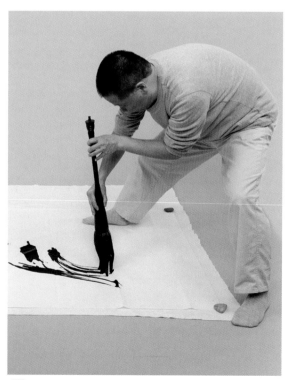

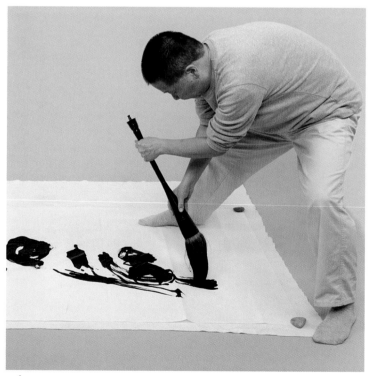

5 Move your body weight to the left and pull the brush down before flicking it back up and repeating the vertical stroke.

6 Carry on, continuing the left-hand side of the sword character.

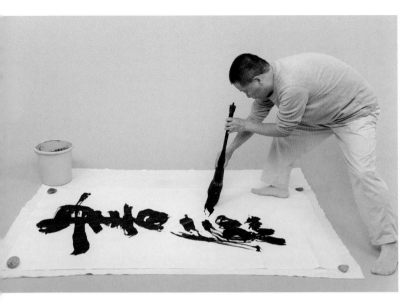

7 When the left is finished the brush should move to the right, followed by your body weight, ensuring that you are still holding the brush directly in front of you.

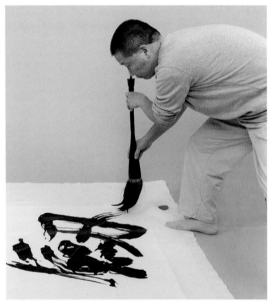

8 Move back, your body position following your brush stroke comfortably. Use your whole body rather than just your arms.

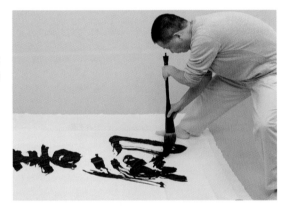

9 Toward the end, the brush is getting drier, so lift it carefully from the paper, making more scratchy, less defined marks called "the flying white" which contrast to the dense, wet ink used at the start.

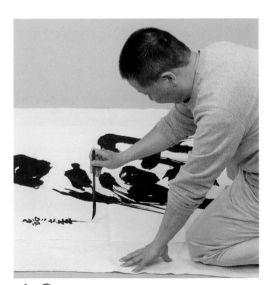

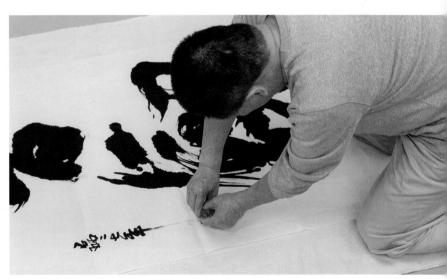

10 Put your big brush back in the container and find a space on the left of the artwork to add your signature and the date. Write with a small brush.

| | Finally, press a seal with red ink.

Wood Strip Book

Easy to produce and make in large quantities, the wood or bamboo strip roll was the earliest type of book in China. The vertical strips of early books ensured that Chinese writing ran from top to bottom rather than right to left, and this has remained to the present day. As the Chinese language still calls an editor a "binder", this ancient technique is ideal for making a very different but evocative sort of calligraphy artwork.

MATERIALS

- Wood strips, ⅜in. wide
- Saw
- Sandpaper
- File
- Brush
- Ink
- Pencil
- Strong thread

1 Measure and cut the wooden strips into equal lengths of approximately 12in. Use sandpaper to smooth off any sharp edges.

2 Place the strips on the table and measure the area required for writing. Mark the top and bottom with pencil marks and use a metal file to make the small indentations that mark the writing area and will act as grooves for the thread.

TIPS
- The text is the famous 2,000-year-old "1,000 character text" in the Bamboo Strip script, based on the Han Official script.
- Although it describes the entire history from creation to the present day, each character appears only once.
- Throughout Chinese history children have learnt this text as they begin to learn calligraphy.

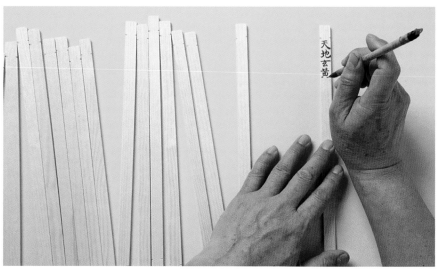

3 Before you start the calligraphy prepare your table and imagine how the whole book will look to determine the size of the characters.

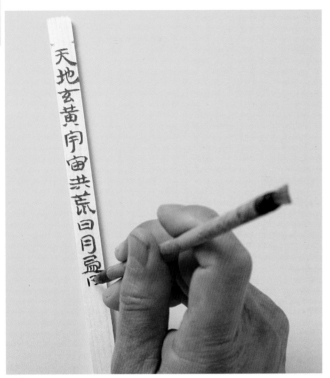

4 Keep the brush flowing smoothly, pressing up and down as well as rotating it to keep the tip smooth, so that the small characters remain clear.

5 When you have filled each strip with characters, turn it over and number it in pencil so that you do not lose the order.

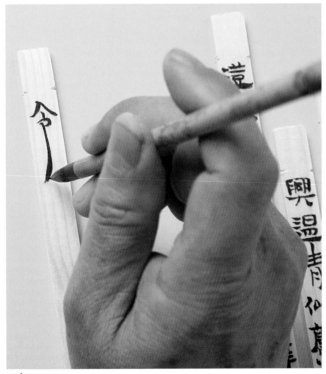

6 Let the brush follow your feelings. In certain characters you can emphasize the last stroke in a long vertical goose tail to make a contrast in the composition.

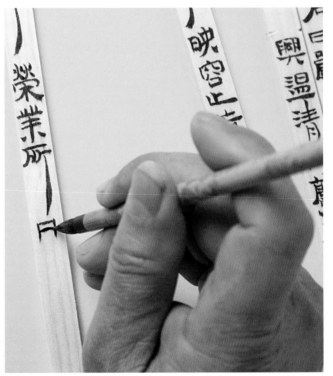

7 As a further contrast, make the following character small and neat again.

8 When the writing is complete, start binding. Prepare two lengths of string, each four times the width of the strips. Fold the string in half and make a simple knot around the top grooves of the last piece.

9 Lay the following strips on the table and continue to bind them one by one, placing them tightly next to each other.

10 When you have only one strip—the first—remaining, put it in place and tie a firm double knot to hold the whole book in position.

11 Twist the remaining lengths of string between the palms of your hands so that they turn over and over on themselves.

12 As you let go, the strings will automatically twist together into a single length.

13 Make a knot at the end of the length to stop the strings unravelling. Use this length to wrap around the rolled book and keep it in place.

Tang Dynasty Fan

As fans have become an integral part of Chinese culture, appearing in many stories, the making and decorating of fans has became a specialist art form. The decorated fan, while protecting against the intense summer heat, also has the ability to educate —the most popular technique is to write a poem or simple phrase in big characters; the irregular shape of the fan also adds interest for the calligrapher.

MATERIALS

- Ready-made fan
- Brush
- Mineral blue paint
- Calligraphy brush
- Seal
- Seal ink

TIPS
- Calculate the number of folds on the fan and the length of the message you want to write, then work out how many characters will fit in each line.
- This Tang-dynasty poem describes a scholar facing beautiful scenery in an ancient site:
 On a rainy day by the river with new, green grass. Six dynasties just like a dream passing by. All that's left is a bird singing in this empty space. Only the willows, showing no emotions, standing still for ten miles along the dam, like a green mist, remain.

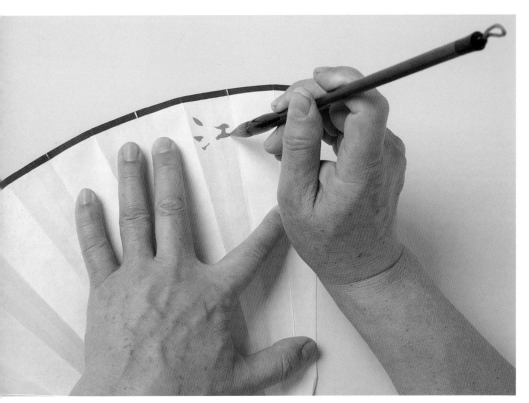

1 Calculate the number of characters, balancing short and long lines so that the characters do not clash with each other as the fan narrows. The first character, *jiang*, means river.

2 The second column describes a falling shower of rain.

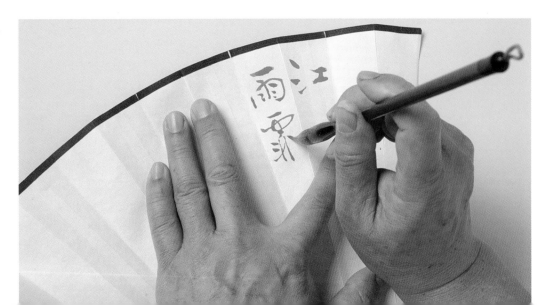

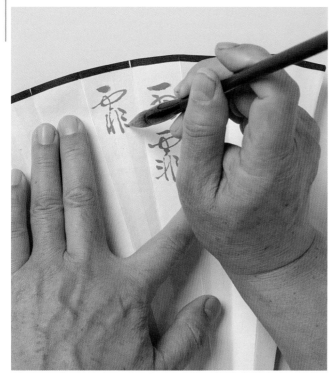

3 Because the description of the falling rain repeats a character, the second should be in a different column and written in a slightly different way—here the dots are now linked into a vertical stroke.

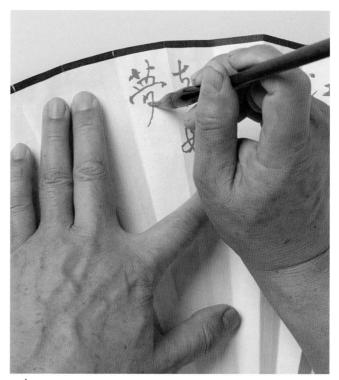

4 Emphasize an important point by making a character larger: here *meng*, meaning dream, is bolder than the surrounding characters.

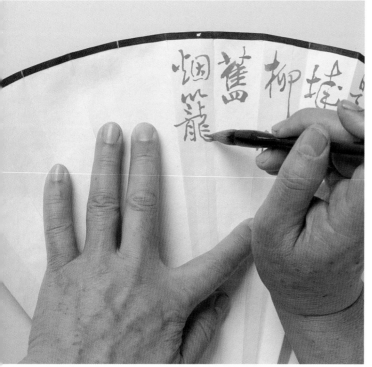

5 These two characters mean "mist-shrouded" so let your brush flow to enhance the effect.

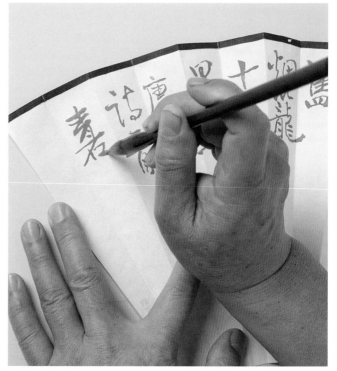

6 The signature following the poem occupies a column of its own.

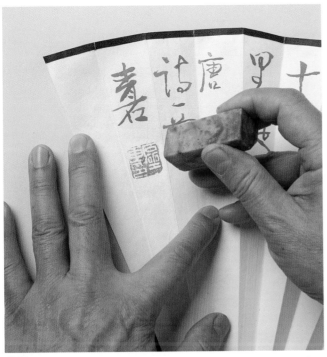

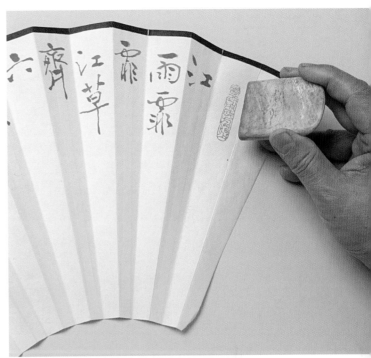

7 Print your seal underneath your signature, following the shape of the calligraphy.

8 Finish by adding a Commencing Seal beside the start of the poem to balance the whole composition.

STANDARD SCRIPT

If a poem is quite short you can put two poems on one fan. The first is a description of China's ancient capital, Nanjing. The second celebrates the coming of Spring:

The wild grass flowers along the Phoenix Bridge, and the sunset falls on the Black Dress Alleyway. The swallows that once lived under the eaves of the palace now fly into the ordinary people's home.

The spring arrives when you see a dragonfly landing on the little sharp tip of the lotus leaf rising out of the water.

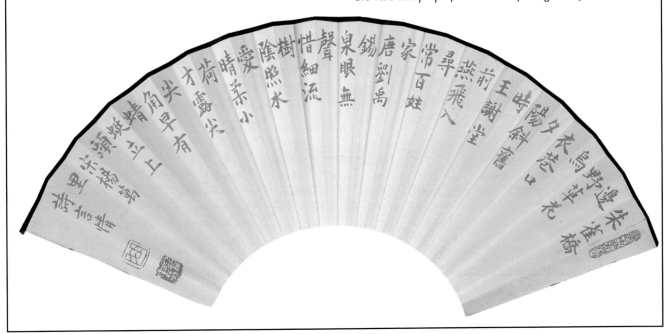

Nameplate

A nameplate in China is called a *bian er. Er* means "forehead," while *bian* means '"wooden plate." Usually hung above a gate or indoors, high up in the central hall, they give the first impression of your house or business, showing who you are and your position, just like a person's face. Different colors and scripts are significant. For example, Standard script is used for serious place names, Running script for artistic use, Zhuan script for intellectual places, and Pictographic for modest or personal signs.

MATERIALS

- Wooden board
- Matte latex paint
- Large paintbrush
- Large calligraphy brush
- Gold calligraphy paint
- Small calligraphy brush
- Red paint
- Varnish

TIPS

- Let the color combination help give an impression.
- Don't rush to paint on the final board: do your design and practise on paper before you start the final work.
- Write slowly: use the brush like a chisel to cut into the wood to give the text sincerity and seriousness. The writing must not be quick or careless.

1 Cover the board with an even layer of black matte latex paint using the large paintbrush.

2 When dry, use gold paint and a big brush to write the sign. The first character, *liu*, means "flowing."

3 Because this is Pictographic, write the second part of the character slightly higher to break the balance and add interest to the character.

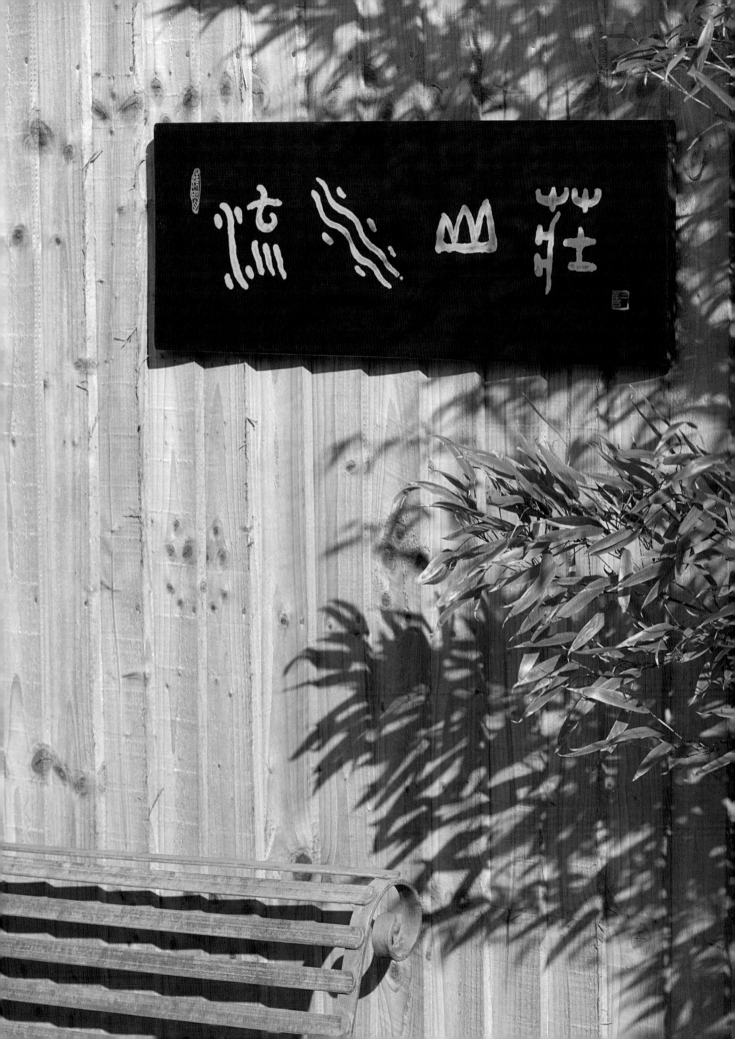

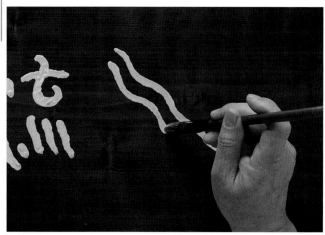

4 The water, *shui*, provides a chance to make a serious signboard more artistic, so extend the character diagonally.

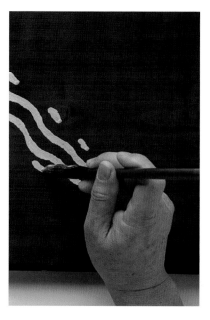

5 Make the dots along the winding lines all slightly different sizes.

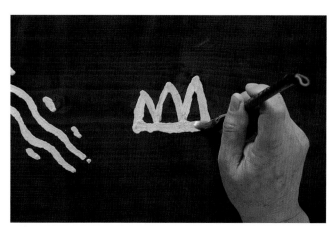

6 To contrast with the character for water, place just the mountain character, *shan*, beside it.

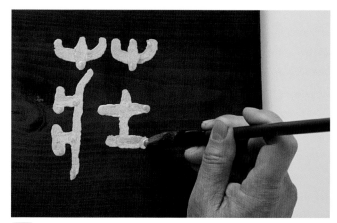

7 The character for village, *zhuang*, is at the end of the board so make it more serious and stable to anchor the text.

8 Because normal seal ink will not work on wood use red paint to draw a seal in the place of the signature.

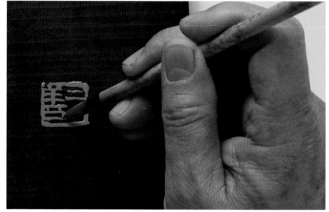

9 Fill the frame of the seal with the characters, showing either your signature or any other message.

10 At the top left draw a commencing seal to balance the composition.

11 The message means "carefree" to match the feeling given by the sign.

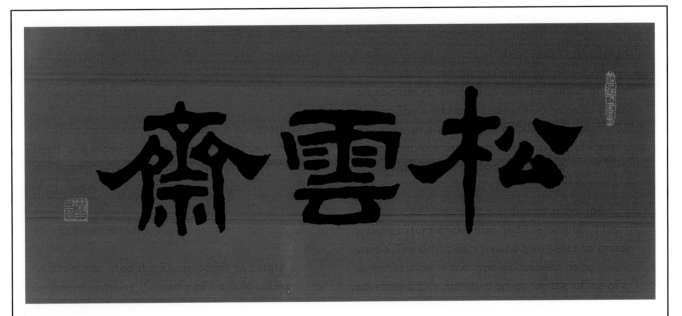

ZHUAN SCRIPT

Song yun zhai
Pine cloud studio

An artist has used the Zhuan script to create a signboard showing the name of his studio. Like the Pictographic script, the Zhuan gives a more old-fashioned impression and emphasizes the artistic nature of the man and the output of his studio. The bright background also helps to create an impression of the type of business being advertised. Use Standard script for the office of a professional like a doctor or a lawyer.

Classic Book Binding

The invention of paper in the Han dynasty and the use of silk ensured that the ancient wooden strip books developed into hand scrolls. These were then transformed into easy-to-read folded albums and even later into spine-bound albums which were simple to handle and protect. This type of butterfly-bound book continues to be used today, usually made with indigo blue covers around white, cream, or pale yellow paper.

MATERIALS

- Blue paper
- White calligraphy paper
- Large paper clip
- Ruler and set square
- Craft knife
- Awl
- Thick needle and thread
- Scissors
- Brush
- Ink
- Seal and seal ink

1 Cut 16 sheets of paper into squares and fold them all in half.

2 Cut and fold the blue covers into the same size as the white paper.

3 Hold them together and line up the folded edge by gently tapping the bundle of papers on the table.

4 Hold them firmly and use the paper clip to keep them in position.

5 Use the set square to find the right angle by placing it along the folded edge and place the metal ruler along it.

6 Use the craft knife to cut the edge, then straighten the two other edges by moving the set square and ruler around, leaving the papers as a perfect rectangle.

7 Use an awl to make four holes along the long side opposite the folds about ⅜in. in from the edge.

8 From the middle of the book push the needle through the second hole out through the front, leaving about 3in. of thread inside the book.

9 Take the thread immediately around the spine and bring it up through the same hole, then take it along the front and down the first hole. Again take the thread immediately around the spine and down through the same hole. Take the thread around the edge of the book before again taking the thread through the first hole.

TIP

• Because the paper is absorbent, place spare paper behind the sheet being written on to protect the rest of the book.

10 Continue, following the order shown in the diagram opposite, taking the thread to the other end and repeating, before turning it around the edge of the book.

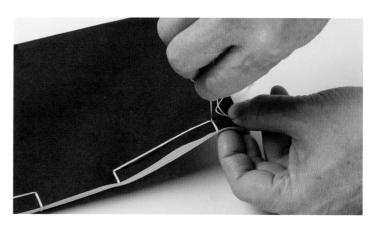

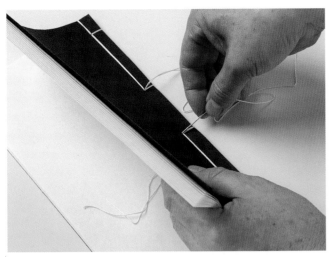

11 The final stitch goes back through the second hole to meet the length of thread left at the beginning.

12 Tie the two ends in a tight knot inside the book.

13 Hide the knot by cutting off the extra thread.

14 Cut a strip of paper and stick on the front cover and write on the name or title.

15 Finally add a seal, in this case a dog indicating the book owner's sign of the zodiac.

SEWING ORDER

Bring the thread up through the hole to the right of center, as shown in Step 8, and take it around the spine to bring up through the same hole. Then move along the top of the book to the end hole and, following the order shown below, tighten the thread around the spine. Finish by bringing the thread back up to the start of the thread (movement 16 below) and tie the two ends together in a knot (see Step 12).

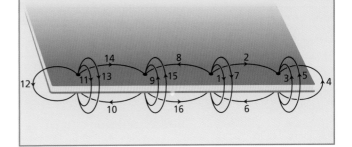

GLOSSARY
Names

Western names do not have their own individual characters in the Chinese language and they are not able to be directly translated into Chinese either. Instead, they are written by matching the phonetic characters for each syllable and combining them to make up the word. In this way, any name can be transposed into Chinese. Included here are fifty names for both girls and boys. If the name you wish to write is not included, you can make up your own combinations of characters to reach the desired sound.

FEMALE NAMES

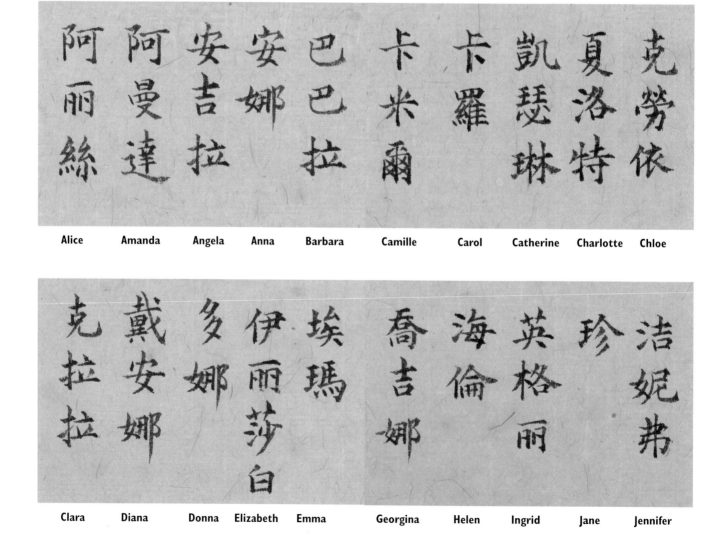

| Alice | Amanda | Angela | Anna | Barbara | Camille | Carol | Catherine | Charlotte | Chloe |

| Clara | Diana | Donna | Elizabeth | Emma | Georgina | Helen | Ingrid | Jane | Jennifer |

佳西卡	珠恩	喬安娜	凱倫	凱塞林	金伯麗	勞拉	李	雷興妮	林達
Jessica	Joan	Johanna	Karen	Kathleen	Kimberley	Laura	Lea	Leonie	Linda

丽莎	露易絲	露西	瑪格麗特	瑪麗亞	瑪蒂爾達	麦甘	米西爾	南希	奧爾嘉
Lisa	Louise	Lucie	Margaret	Maria	Mathilde	Megan	Michelle	Nancy	Olga

帕美拉	羅絲瑪丽	露絲	桑德拉	莎拉	索菲	斯苔芬妮	蘇珊	塔妮亞	佐伊
Pamela	Rosemary	Ruth	Sandra	Sarah	Sophie	Stephanie	Susan	Tanya	Zoe

MALE NAMES

亞當　阿德連　阿倫　阿伯特　亞力山大　安德魯　本捷明　布蘭頓　布萊恩　查爾斯

| Adam | Adrien | Alan | Albert | Alexande | Andrew | Benjamin | Brandon | Brian | Charles |

克里斯托弗　克萊門特　考納　丹尼爾　大衛　迪倫　唐納德　愛德華　費利克斯　弗朗克

| Christopher | Clement | Connor | Daniel | David | Dillon | Donald | Edward | Felix | Frank |

蓋瑞　喬治　蓋伊　哈里　亨利　伊恩　杰克　詹姆斯　捷森　約翰

| Gary | George | Guy | Harry | Henry | Ian | Jack | James | Jason | John |

尼克萊斯　尼考拉斯　麦克　馬修　馬克西米安　馬克　盧克　嘉斯廷　喬士華　約瑟夫

Joseph	Joshua	Justin	Luke	Mark	Maximillian	Matthew	Michael	Nicholas	Nicolas

威廉　托馬斯　史蒂文　塞巴斯蒂安　羅伯特　理查德　彼埃爾　彼德　保爾　欧文

Owen	Paul	Peter	Pierre	Richard	Robert	Sebastien	Steven	Thomas	William

Proverbs and Poetry

Chinese proverbs are famed for their beauty and wisdom. The following selection have all been written in the four main scripts – the much smaller number of pictographic characters means that some cannot be fully rendered in the most ancient script. Choose whichever style best reflects the piece you are creating.

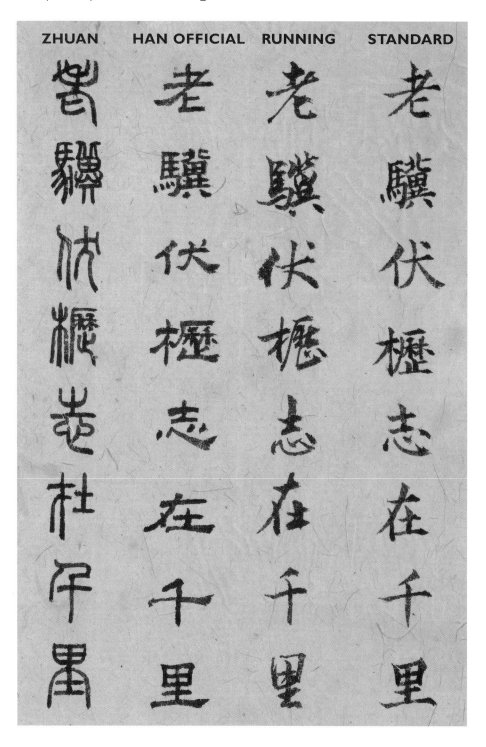

ZHUAN	HAN OFFICIAL	RUNNING	STANDARD

The old horse lowers his head and pulls the wagon slowly forward. His ambition is to journey a thousand miles.

**Cao Cao
(Three Kingdoms period)**

You and I are
the closest friends
in the world.
Wherever we may
be, even on
opposite sides
of the world, we
will always be
together.

Wang Bo (Tang dynasty)

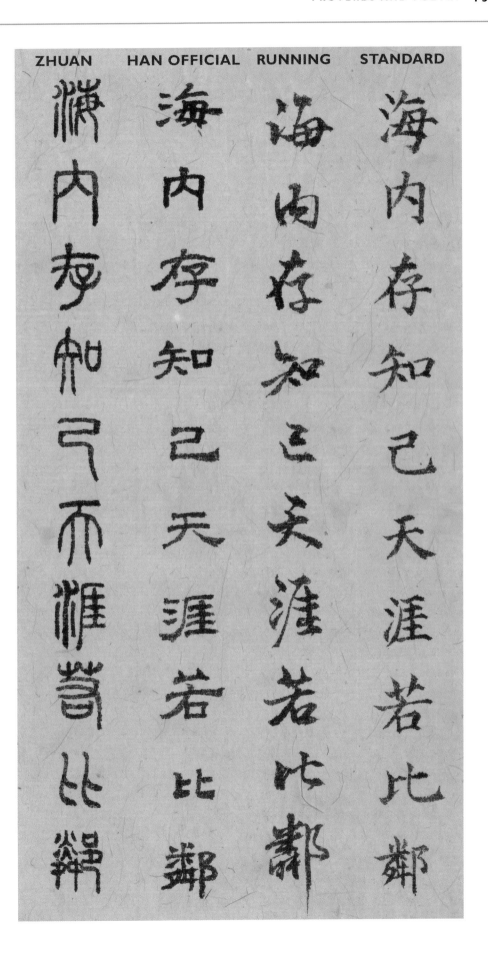

ZHUAN HAN OFFICIAL RUNNING STANDARD

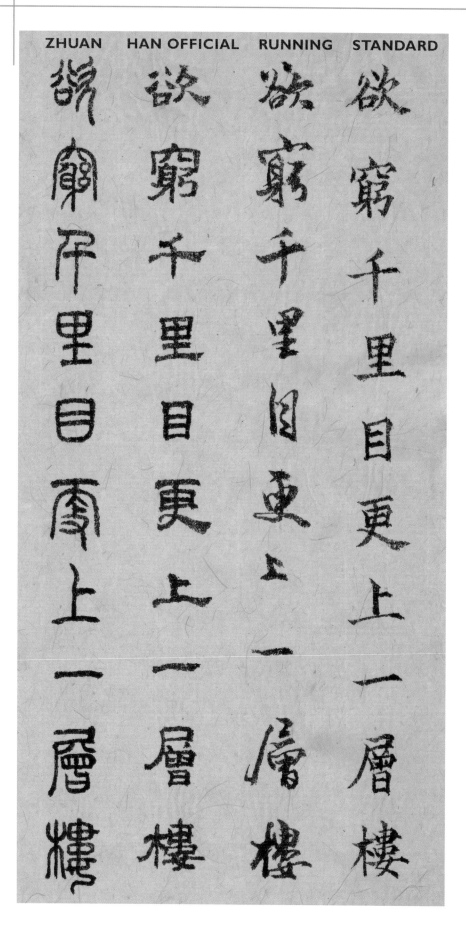

ZHUAN **HAN OFFICIAL** **RUNNING** **STANDARD**

To see further,
stand higher.

Wang Zhi Huan (Tang dynasty)

The wild fire will never burn out the grass of the field. When the wind blows in spring, the shoots will rise again.

Bai Ju Yi (Tang dynasty)

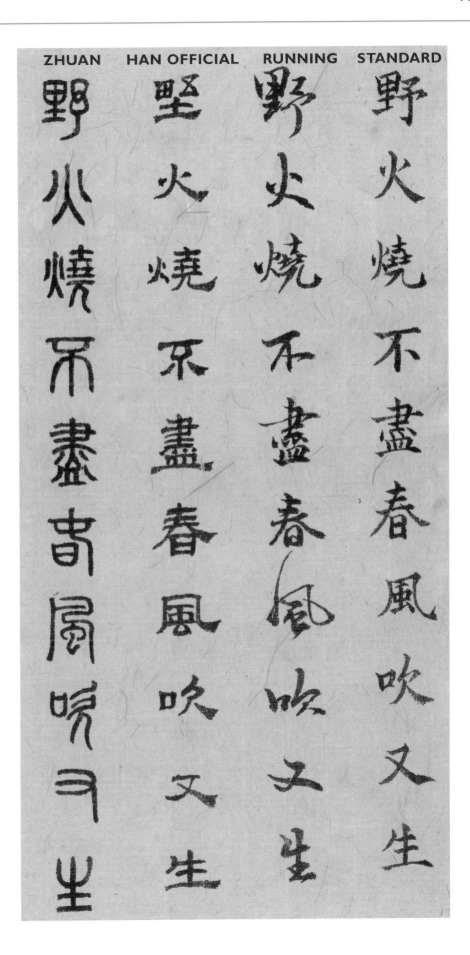

ZHUAN HAN OFFICIAL RUNNING STANDARD

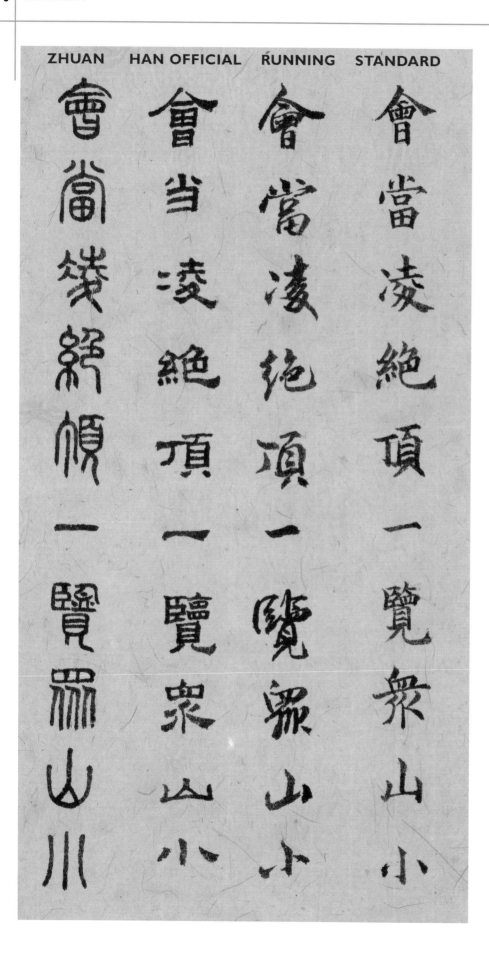

ZHUAN HAN OFFICIAL RUNNING STANDARD

When you have
finally reached
the highest
peak, all other
mountains
beneath your gaze
are suddenly
small.

Du Fu (Tang dynasty)

All of us in the world are brothers, even the man who comes past as a traveler.

Anonymous (Han dynasty)

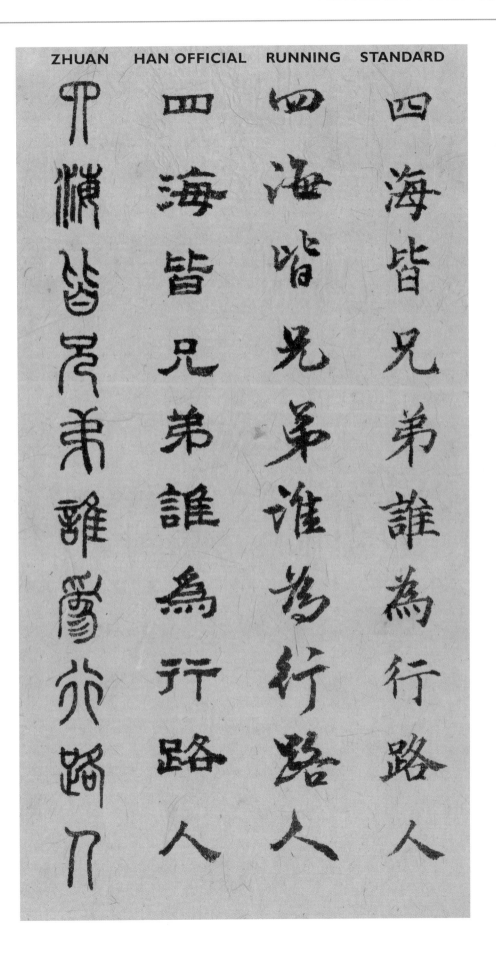

ZHUAN HAN OFFICIAL RUNNING STANDARD

四海皆兄弟誰為行路人

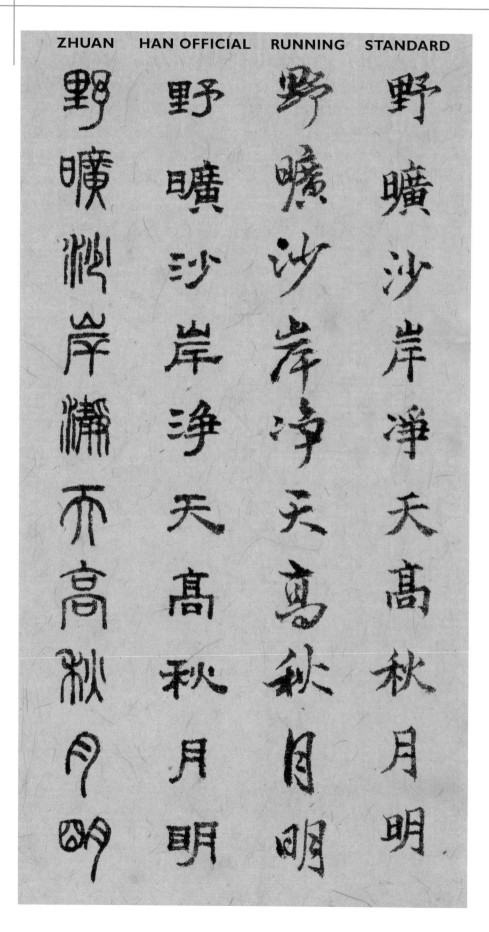

ZHUAN HAN OFFICIAL RUNNING STANDARD

The land lies broad
The shore is clean
The sky rises high
The moon shines
bright

Xie Lang Yun (Six dynasties)

The sound of a cicada makes the forest more quiet. The singing of a bird makes the mountain more tranquil.

Liu Yun (Six dynasties)

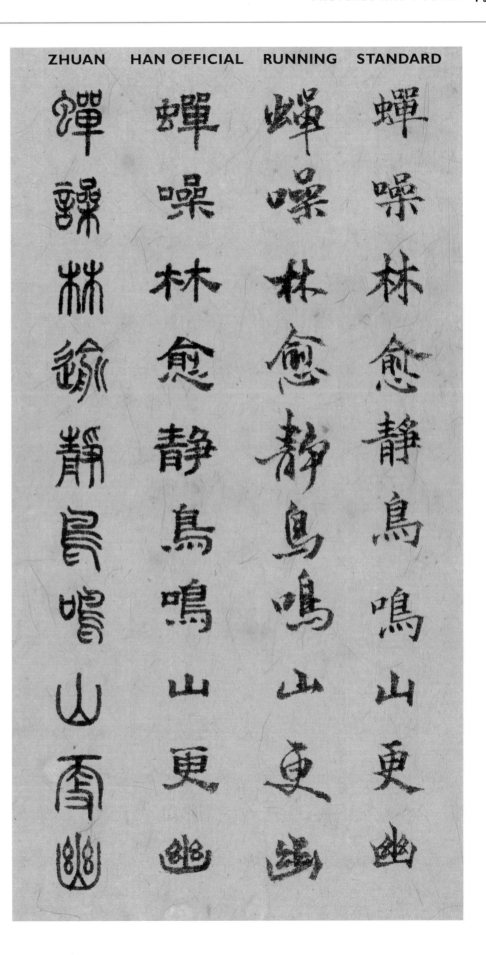

ZHUAN HAN OFFICIAL RUNNING STANDARD

ZHUAN **HAN OFFICIAL** **RUNNING** **STANDARD**

讀書破萬卷下筆如有神

If you have read tens of thousands of books the spirit of learning will flow from your brush as you write.

Du Fu (Tang dynasty)

The fragrance
is already spread
without shaking
the tree.
The blossom
flying over
without the wind

Wang Ji (Six dynasties)

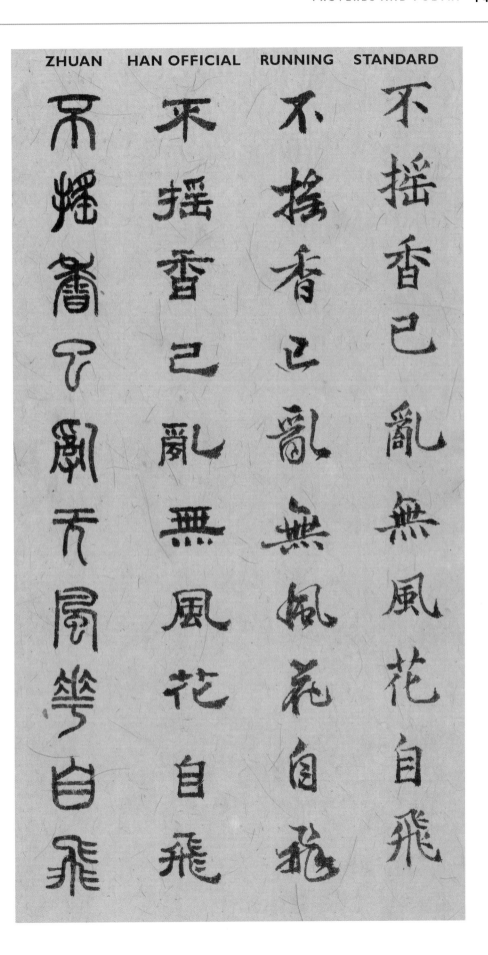

ZHUAN HAN OFFICIAL RUNNING STANDARD

Index

Acknowledgments

Since the successful publication of **The Simple Art of Chinese Calligraphy**, CICO Books and I have both wanted to introduce the other main scripts of Chinese calligraphy to a worldwide readership. I would like to offer my great thanks to Cindy Richards, Liz Dean, and Sally Powell of CICO Books – without the work of the exceptional team from the publisher, this new book would not have been possible.

I would like in particular to thank Robin Gurdon for his work on the text, Ian Midson for his design, Geoff Dann for his beautiful photography, and Stephen Dew for artwork. And finally, I am very delighted to be able to congratulate all those people have become experts of Chinese calligraphy.

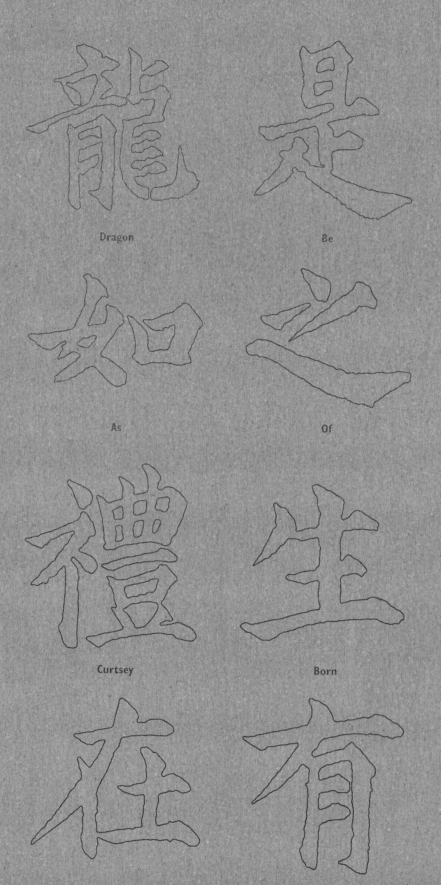

龍

Dragon

如

As

禮

Curtsey

在

At

是

Be

之

Of

生

Born

有

Have

悟

Realization

經

Bible

The rules of the Standard script are identical to the earlier scripts, the difference is that they must be followed strictly with no exceptions.

Again start on the left, working from top to bottom. Write the outside of box motifs first, filling in and then closing up with the bottom horizontal.

If you follow these general rules you will quickly get used to the sequence needed.

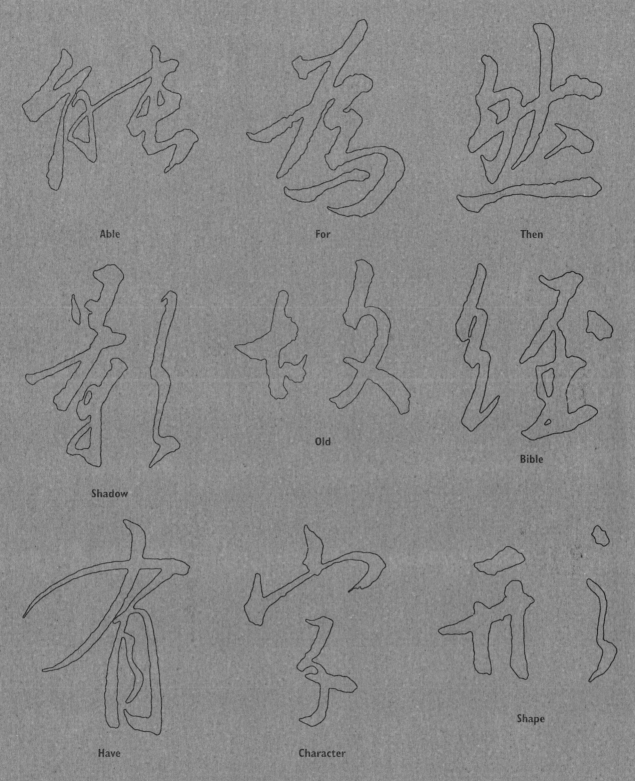

Able

For

Then

Shadow

Old

Bible

Have

Character

Shape

The basic rules of stroke sequence follows the Standard script but some are now linked in continuation and on some occasions, if it is convenient to the writing, the sequence can be slightly changed. For example, when writing *you*, meaning "have," in Standard script you should begin with the horizontal, followed by the left aside. In Running script start with the left aside and continue the curve into the horizontal so the brush easily moves down and back up to make the frame at the bottom of the character. The two small strokes inside have also been linked up into a curve.

Magic Paper

Magic paper is an invaluable tool for the calligrapher. When you brush water over the paper the area covered darkens, only for the mark to disappear as the paper dries. This allows you to repeat individual strokes and whole characters over and over again.

To use the magic paper, first tear out the sheets from the book. Set up your work table as though you were going to write calligraphy (see page 24), but with a pot of clean water instead of ink.

Using a regular mixed-hair brush write each stroke in one go, never repeating or correcting a line. Don't try to perfectly fill in the outline: instead, think about the structure of the character as a whole. As you work you will quickly see how wet to make the brush to create a clean character. If you make a mistake, just wait for the paper to dry before trying again.

Try writing the character for "calligraphy" in the different scripts (see overleaf) and then a selection of characters written in each of the five major scripts.

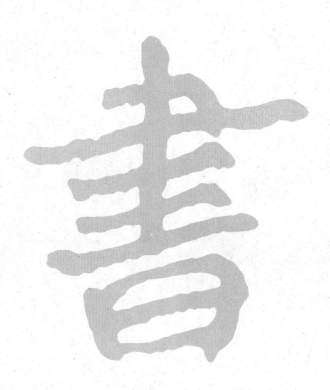

Please turn over